IMAGES
of America

SUMNER

IMAGES
of America

SUMNER

Paul J. Rogerson
and Carmen M. Palmer

ARCADIA
PUBLISHING

Published by Arcadia Publishing
Charleston, South Carolina

Printed in the United States of America

Library of Congress Control Number: 2013935712

For all general information, please contact Arcadia Publishing:
Telephone 843-853-2070
Fax 843-853-0044
E-mail sales@arcadiapublishing.com
For customer service and orders:
Toll-Free 1-888-313-2665

Visit us on the Internet at www.arcadiapublishing.com

Dedicated to the people of Sumner.

CONTENTS

ACKNOWLEDGMENTS

Thank you so much to the people of Sumner, who shared their families, friends, and memories with us to make this book possible. Sumner has a rich heritage that could fill 10 books, so we are sorry that we had to be selective. In addition to personal histories, information came from *The Sumner Story* by Amy Ryan, *Little Histories: Levant F. Thompson* by Jack R. Evans, and the former *Sumner News-Index*.

Special thanks to H. Carol Anderson, Robert Barnum, Jane Brazda, Dave Curry, Rosalee Divelbiss, Pat Duffy Jr., Hazel Freehe, Sharon Guyette, Bruce and Martha Hallman, Ed and Carolyn Hannus, Donna Hardtke, Ginny Weick Henderson, Karl and Barbara Keck, J. Larson, Roger Neill, Charles Ochsner, Stacey Ota, Carolyn Pasquier, Mary Sanford, Kareen Shanks, Beverly Shilling, Anne Sonner, Martha Sonneville, Randy Strozyk, Ernie Trujillo, and Ryan Windish.

Thank you also to Ron and Nick Leslie and the Washington Rhubarb Growers Association; Gene and David Hammermaster of Hammermaster Law Offices; Ann Cook of the Sumner School District; Marc Blau, who saved Lucille Merritt's scrapbooks and donated them to the Sumner School District; Dave Radcliffe and Steve Fowler of The Old Cannery Furniture Warehouse; Shelly Schlumpf of the Puyallup/Sumner Chamber of Commerce; Glenn Whaley of Spartan Agency LLC; and the Tacoma Public Library.

We also owe a big thanks to Sumner mayor Dave Enslow, city administrator John Galle, and all the staff of the city of Sumner who supported us while we hogged the scanner and had our noses deep in the 1920s. The authors' royalties from this book will go back to the city of Sumner, as we relied on their resources to make this history happen.

INTRODUCTION

Native Americans settled here hundreds of years ago. Americans and Europeans began coming with wagon trains, and Sumner's settlers were the first to deviate from the Oregon Trail and try the Naches Pass in 1853. From that group, families signed up for Donation Land Claims. Familiar names include William M. Kincaid, Jonathan W. McCarty, and Abram Woolery. In 1873, George Ryan came to the area from Baraboo, Wisconsin. In 1883, John and Nancy Kincaid, along with Lucy and George Ryan, platted the town on the 160-acre Kincaid Donation Land Claim. George Ryan purchased 40 acres from Main Street to Park Street from Laura Seaman Kincaid. When the town incorporated in 1891, Ryan was its first mayor.

As they farmed the fertile valley soil left by past eruptions of nearby Mount Rainier, settlers endured floods, fights, blight, and all the challenges that come with starting a brand new community. Even the name was a bit of a challenge. The community was originally called Stuck Junction, and then J.P. Stewart established a post office covering the future Puyallup-Sumner area, which he named Franklin after his New York hometown. The post office said there were too many Franklins in Washington, so they required the community to choose another name. George Ryan, John Kincaid, and L.F. Thompson met at Joe Kincaid's store but could not agree on a name. They each put a choice into a hat and asked a boy to draw out a slip. The resulting slip said Sumner, L.F. Thompson's suggestion in honor of Charles Sumner, a US senator and prominent abolitionist. When Thompson had traveled to Sumner in 1848, he stopped in Buffalo and saw many of the "distinguished pioneer anti-slavery men of the nation," as he wrote in his autobiography in 1892, which may explain his suggestion.

The story of Sumner's founding and early days is well told by Amy Ryan in the book *The Sumner Story*, written in the 1960s and still available from the Sumner Historical Society. This book does not retell that story. Instead, it is the next chapter—or rather, the next 10 chapters—focusing primarily from 1900 through the 1960s. What happened to Sumner after it was founded? How did the raw dirt and wood become the streets and buildings so many recognize as home today? How did Sumner change and grow with the advent of the automobile, movies, and electricity?

With its picture-perfect Main Street and tree-lined blocks of Craftsman-style homes, Sumner often gets compared to the fictional Mayberry of Andy Griffith fame. But that comparison is not just due to Sumner's physical qualities. As you explore the following pages and get lost in the Sumner of yesteryear, get to know the people who shaped this community—their laughter, hardships, celebrations, and catastrophes. In many ways, the shaping of Sumner in the 20th century is also the shaping of all American small towns, and yet there is plenty that makes Sumner unique, from its name drawn out of a hat to the distinctive flavor of rhubarb.

For example, the Darr brothers appear in some of these photographs. In the early 1900s, Thomas Darr opened a general store, William Darr ran a different general merchandise store, and Ernest Darr opened a stationery store in the post office. One of them even tried operating a skating rink, although the newspaper did not specify which brother it was. However, what may get lost is the

more personal story, including the fact that William's wife passed away when she was very young in 1910, leaving him to raise three children with the help of his brother Ernest. Billy Darr, one of the children, was also sickly throughout his short life and passed away at age 16.

Like the Darrs, there are many other family stories of tragedy and triumph. This book only grazes the surface. But, hopefully, the snapshot offered by this book reminds us that the only constant is change, even in a town as classic as Sumner. The authors cannot count how many different owners and locations there have been for the Berryland Cafe through the decades. Yet, for all its physical changes, sometimes the things that matter most are more similar than people may think. The Berryland has changed hands and locations over the years, but it is still the classic diner where locals go to get breakfast, a burger, homemade rhubarb pies, and the latest gossip. Students at Sumner High School may now be recording their lives through texting and the Internet, but they are still sharing their friends and their fun, just as Lucille Merritt did in the 1920s with her pasted scrapbook and "Kodak snaps."

The Sumner City Cemetery is an often-overlooked community treasure, and its inhabitants include veterans of every American war going back to the Civil War. That may be common on the East Coast, but on the West Coast, it is a sign that Sumner is a rather "old" community in one of the newest parts of this nation. The roots run deep in this fertile valley soil.

In her book, Amy Ryan tells the fascinating story of W.W. Smith, a blacksmith who set up a shop on Sumner's Main Street. He came from Switzerland but first spent some time in Detroit, where he often engaged with an eager youth named Thomas Edison. Smith even gave Edison some space to try out his experiments. When Smith moved west, he sold his shop to Henry Ford. Today, stores continue to be innovative on Main Street and throughout the new industrial section. While the trades are coffee, boutiques, furniture, and plants, the same drive—to make a living, enjoy a home, celebrate with friends and family, and perhaps even affect history—remains.

Through the years, Sumner has evolved from a wilderness farming community to a suburb of nearby Seattle and Tacoma. Despite that shift, the community retains its agrarian flavor and identity through daffodils, rhubarb, parades, Main Street businesses, neighbors who still gossip over the fence, and a fierce treasuring of its history. If you have lived in Sumner all your life, please enjoy the memories this book hopefully brings back. If you are new to Sumner, explore the area's heritage and start to imagine how you now fit into this story. If you like to visit Sumner, hopefully this is a reminder of a place that echoes historical small towns in more ways than just what is seen on these pages.

One

A Tour through Sumner

Sumner's successful business owners built substantial homes and buildings, many of which remain today. Depending on the measurement used, William Kincaid and George H. Ryan both have claims on the title of founder of Sumner. Although called the Ryan House even today, Ryan's home bridges the two families, as it was built from the original cabin of Laura Kincaid Seaman, William Kincaid's daughter. Located at 1228 Main Street, the Ryan House now serves as Sumner's historical museum. Other grand survivors include the Thompson home on Sumner Avenue, the Maple Lawn home on Wood Avenue, the Wright home on Mason Street, and the Ames and Williams homes on Elm Street. Just south of the city limits, the Charles Orton home looks much the same today as it did on the day in 1934 when local bulb growers gathered there to discuss the beginnings of the area's now-famous Daffodil Festival.

Buildings that served as landmarks for earlier generations have not always survived. Grand edifices that are known today only through historical photographs include Ryan's Mill, the striking Shipley Building, the Whitworth College Building, and the old Sumner School. Most can be seen in one or more of the many panoramic photographs of Sumner over the years.

Many of Sumner's neighborhoods remain largely unchanged and offer a glimpse into the past as well. Homes and churches from the early 1900s create streetscapes enjoyed by previous generations. This provides a sense of continuity that anchors the community firmly as it moves forward toward an uncertain future.

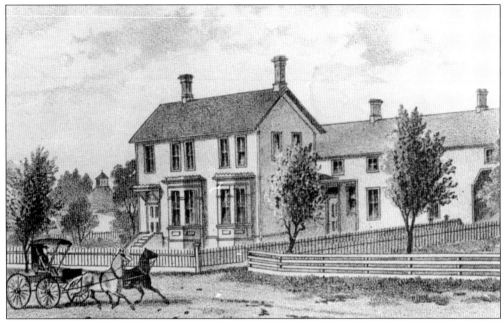

The L.F. Thompson house still stands at 315 Sumner Avenue, on a rise south of downtown that once looked over Thompson's extensive hop fields. Levant F. Thompson, a member of the first territorial legislature, built the house after marrying Susannah Kincaid in 1856. The house featured crystal chandeliers, imported black marble fireplaces, and a mural of hops painted by an Italian artist and topped with moldings of real gold leaf. (Courtesy of Ed and Carolyn Hannus.)

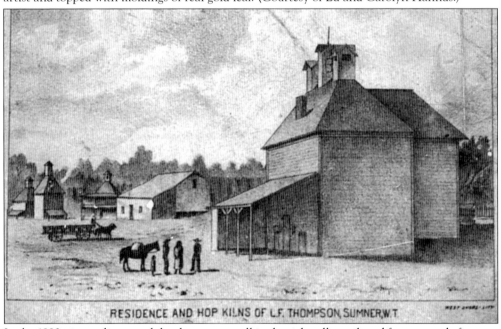

In the 1880s, it was discovered that hops grew well in the rich valley soil, and farmers made fortunes shipping them to breweries. Hops were dried in hop kilns like this one, owned by L.F. Thompson. Within a decade, the hop industry was wiped out by an aphid infestation, and the hop barns, with their many chimneys, became a relic of the past. (Courtesy of Ed and Carolyn Hannus.)

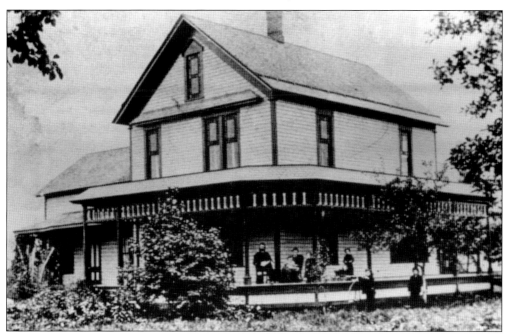

The original portion of the George Ryan House, at 1228 Main Street, was built in 1875, with an addition in 1880. Ryan filed the original plat of the town in 1883 and became its first mayor upon its incorporation in 1891. This photograph shows the Ryan family standing on the wide porch in 1888. The house became the city's library and then the historical museum in 1979. (Courtesy of the City of Sumner/Sumner Historical Society.)

The George Ryan House is on the far left in this view of Main Street in the early 1890s. The hop barn on the right was built on the Ryan property and then overtaken by vines after the hop boom ended. (Courtesy of Hammermaster Law Offices/Sumner Historical Society.)

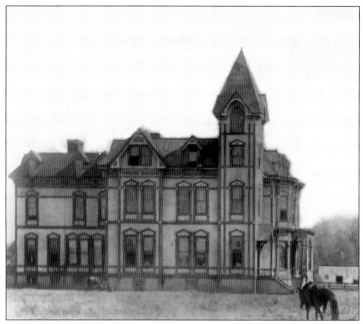

Whitworth College, today one of the larger Presbyterian universities in the nation, was born in Sumner in 1890. The campus and this grand classroom building were on the block bounded by Alder and Park Streets and Academy and Cherry Avenues. In 1899 the college moved to Tacoma, and later to Spokane, where it is located today. This building was demolished after a fire in 1918. (Courtesy of the City of Sumner/Sumner Historical Society.)

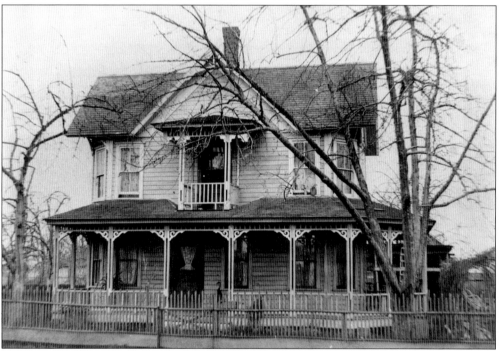

The Thomas Anderson "T.A." Wright home on Mason Street still stands, although it has been altered many times over the years. Wright came to Sumner from the Arkansas Ozarks in 1888 with his brothers and sisters. Their parents dreamed of coming west and had planned the trip the previous year. Both of Wright's parents died from what was then known as "quick consumption," but the children, including T.A., continued to follow their parents' dream despite their grief. They traveled by covered wagon to The Dalles, Oregon, and finally to the Puyallup Valley. T.A. Wright raised his family in Sumner until his death in 1931. (Courtesy of Dave Curry.)

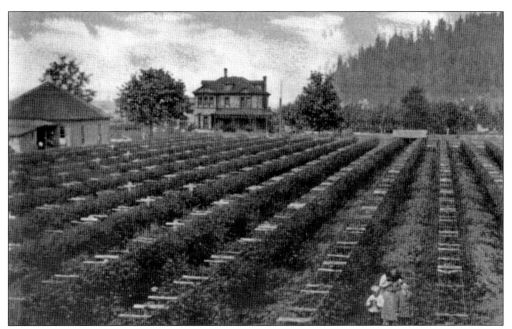

The A.L. Ames house was built in 1892 and still stands at 15405 Elm Street. A Civil War veteran, Ames came from Massachusetts and lived in Tacoma for a year before building this house for his family. In 1907, he moved to Toppenish. He passed away in 1917 and is buried in the Sumner City Cemetery. Later, the house became part of the Sidney Williams estate. (Courtesy of Bruce and Martha Hallman.)

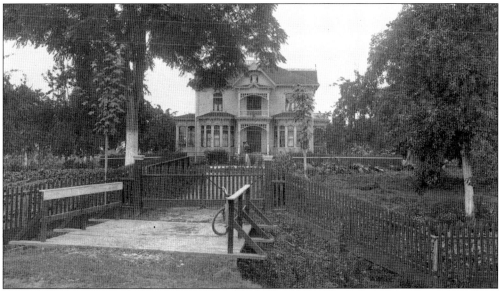

This home, at 1711 Elm Street, was listed in the National Register of Historic Places in October 1984. It was built in 1889 by Herbert Williams for his wife, Lola. John Driskill was the contractor. It was lavishly detailed and financed by the fortune Williams made in the booming hops industry. His brother Sidney Williams built his house next door. This home was purchased by Adolph and Helene Loncke around 1900 and later served as a gift shop and teahouse. (Courtesy of the Tacoma Public Library, Wilhelm collection.)

Locally famous as the home of the Daffodil Festival, the Charles W. Orton farm is seen here around 1920. Local bulb farmers first discussed the idea for a festival celebrating their industry here in 1934. The farm is at 7473 Riverside Road East in Sumner. Built in 1914, it was listed in the National Register of Historic Places in July 1983. (Courtesy of the Tacoma Public Library, Boland collection.)

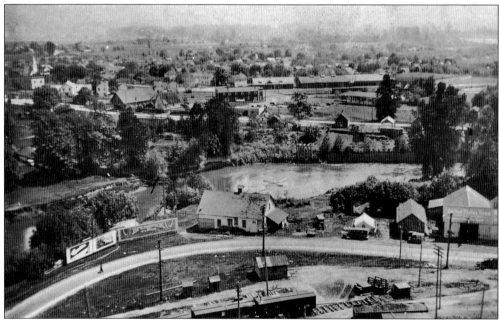

This view of Sumner from the east in the early 1920s shows the Sumner Garage on the right. Also seen on the bank of the river are the beginning forms for the Stuck River Bridge, which was completed in 1927 and served as the connection between these two sections of Sumner for over 80 years. (Courtesy of Kareen Shanks.)

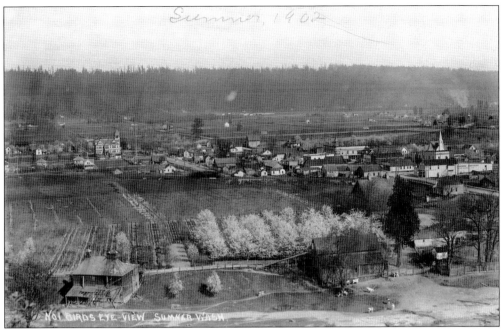

This 1902 bird's-eye view of Sumner features prominent buildings including the school (left center with large tower), the Shipley Building (center right with pointed tower), and the Christian church (far center right, white steeple). The Shipley Building burned down in 1914 and the school followed in 1924. The church is also gone. (Photograph by Lucille Merritt, courtesy of Sumner School District/Sumner Historical Society.)

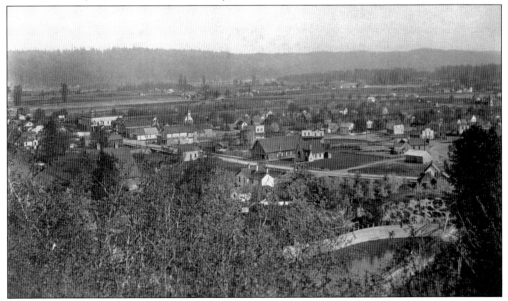

This photograph, also probably from 1902, shows Main Street running diagonally through the image from beyond the Shipley Building. Wooden floodwalls had recently been built on the east side of the Stuck River, in the foreground. Ryan's Hall sits beside the Presbyterian church, facing Main Street in the center. Northern Pacific Railway's water tank sits trackside, just behind and to the left of Ryan's Hall. (Courtesy of Hammermaster Law Offices/Sumner Historical Society.)

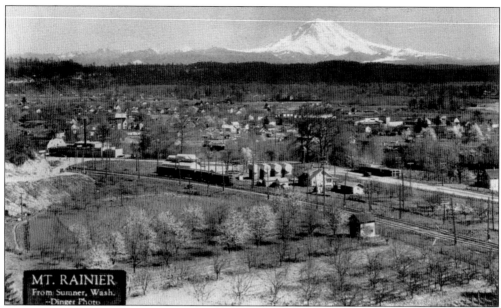

With snow-capped Mount Rainier in the distance, Sumner is seen here on a sunny spring day. The Milwaukee Road's railroad tracks skirt the west edge of the town. This photograph was taken sometime after 1925, as that was the year Seattle photographer Frank Dinger bought the Green photograph studio in Sumner. (Photograph by Frank Dinger, courtesy of Puyallup/Sumner Chamber of Commerce.)

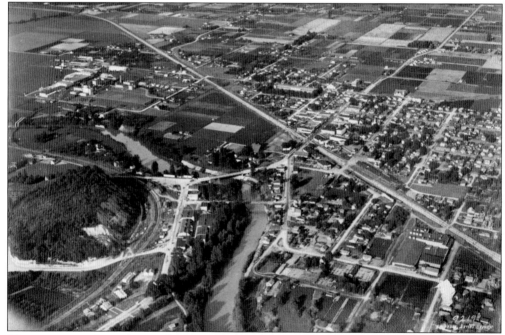

The emergence of a modern grid street system is evident in this aerial photograph from 1929. The Milwaukee Road tracks bend around a hill on the left, while the Northern Pacific's run straight through town from the bottom right to the upper left. Main Street runs from the extreme upper right corner through downtown towards the Stuck River. (Courtesy of Ryan Windish, City of Sumner.)

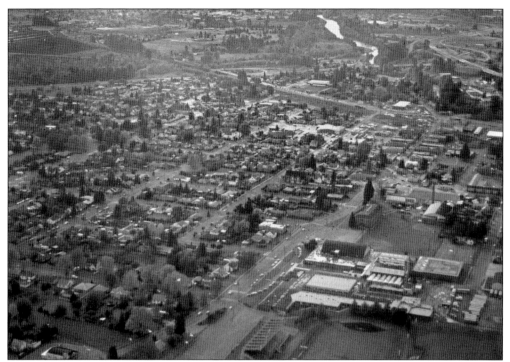

This overhead photograph shows Sumner High School in the foreground and the downtown building farther along Main Street at center right. It is a testament to the wisdom of community leaders that this focus of community life has been retained close to the center of town and adjacent to residential areas. (Courtesy of Roger Neill.)

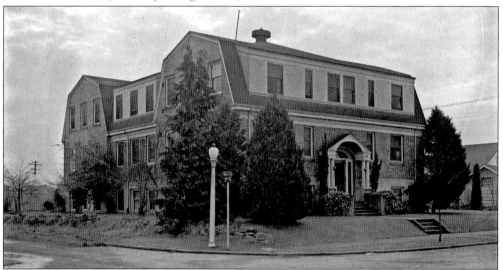

The Weaver Apartments, seen here in 1940 at 1314 Maple Street, were built in 1925 for Ralph and Mamie Weaver, who made the entire first floor their home and rented the rest. William Blackadder designed the three-story Dutch Colonial building with its double gambrel roof at the corner of Maple Street and Wood Avenue. Blackadder also designed the Phoenix Masonic Lodge at 1005 Main Street. His daughter Hazel Knoblauch Freehe became one of the major rhubarb growers in the area. (Courtesy of the Tacoma Public Library, Richards Studio Collection.)

Sumner First Methodist Church, at 901 Wood Avenue, is seen here in the 1930s. The church, built in 1923, remains today largely as it is seen here, including the distinctive cross design in brick on the bell tower above the triple-door entrance. (Courtesy of the Tacoma Public Library, Richards Studio Collection.)

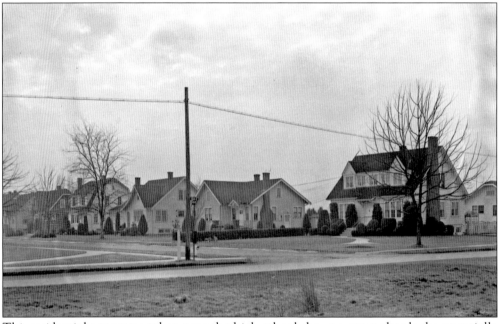

This residential panorama taken near the high school shows a street that looks essentially the same today. The photograph, taken in January 1940, shows several homes along Lewis Avenue, near its intersection with Main Street. (Courtesy of the Tacoma Public Library, Richards Studio Collection.)

Two

LUMBER, FARMS, AND YEAST

As with most early European settlements, agriculture was Sumner's first industry. Early settlers like George H. Ryan, William Kincaid, and L.F. Thompson made fortunes in the "hop boom" of the 1880s. In 1883, Sumner Lumber Company was established, with Ryan, E.T. Everett, and M.J. Madden as its owners. The mill, at the foot of the hill to the east of town, and the 5,000 acres of timberland on the hill above it provided employment for up to 75 men. Soon, various firms were churning out doors and sashes, shipping brick and tile, and canning produce.

In 1912, Fleischmann's Yeast Company of Cincinnati built what was to become its largest yeast-producing facility. Soon, the Fiberboard Corporation located next door and started providing cardboard for boxes to industries across the region. Other industrial plants followed, including the Hewitt-Lee-Funck Company and its successors, which produced millwork and eventually wooden airplane parts.

Agriculture has not gone away, but rather risen to new levels of organization and productivity. Sumner became the home of the Puget Sound Bulb Exchange, the Puget Sound Vegetable Growers Association, and the Sumner Rhubarb Growers Association.

More recently, a large industrial area north of the city proper has been home to warehouses and manufacturing businesses that build everything from trusses for homes, to coffee, to high-tech tunnel-boring machines.

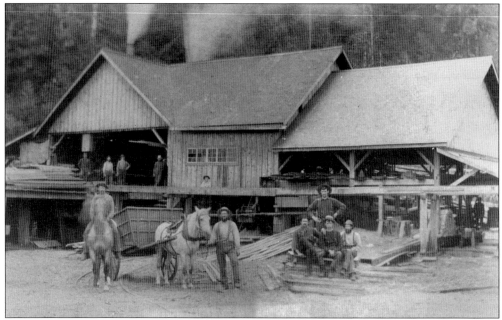

In 1888, George Ryan's Sumner Lumber Company, at the base of the hill east of town, was the principal industry in Sumner. The mill produced dressed and rough lumber, hop and fruit boxes, and water pipe. Timber came from the company's 5,000 acres on the hill above the mill. Ryan's mill burned in the early 1890s. (Courtesy of the City of Sumner/Sumner Historical Society.)

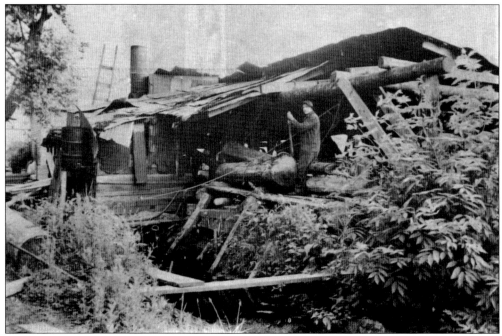

Lumber and logging remained an important industry for Sumner. John Gear is seen here working in his mill on Sumner's East Valley Road in June 1953. Gear was milling lumber in much the same way George Ryan had more than 50 years earlier. (Photograph by *Sumner News-Index*, courtesy of Robert Barnum.)

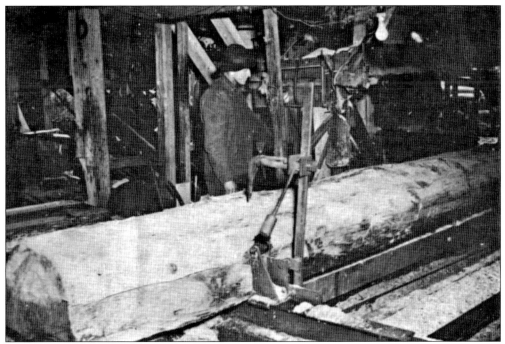

John Gear is seen again in June 1953 as he prepares a log for cutting in his mill along East Valley Road. Gear grew up in a family that was quite wealthy, but ended up living in his "shack." After he died, leaving no heirs, locals practically tore the shack apart, convinced that his family fortune was hidden somewhere. They found nothing. (Photograph by *Sumner News-Index*, courtesy of Robert Barnum.)

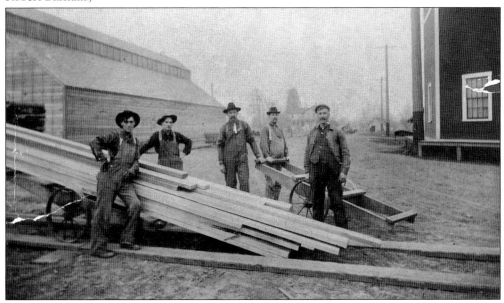

Workers pose at the old planing mill, which was called Morris Manufacturing Company around 1900. They are, from left to right, Lee Morris, Harold Miller, Ed Prizzner, Bill "Ed" Ingalls, and George Hudlee. The site of the mill later became Oz Rogers's Sunset Chevrolet building, at 910 Traffic Avenue. (Courtesy of Kareen Shanks.)

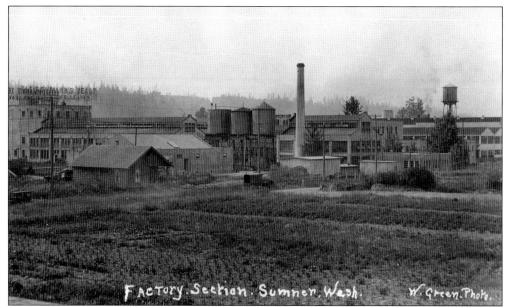

For most of the 1900s, Fleischmann's Yeast Company was a major employer in Sumner. The plant, located along Fryer Avenue north of the downtown area, produced baker's yeast for home and commercial uses. Construction of the Fleischmann's plant began in June 1912. It was the Cincinnati-based company's seventh—and largest—plant. (Courtesy of the City of Sumner.)

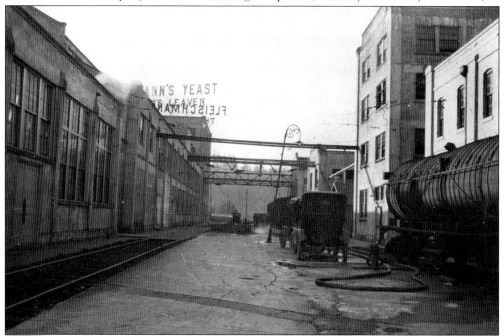

Fleischmann's Yeast Company chose the 12-acre Sumner site because of its abundant artesian water and existing railroad spur. Completed by June 1913 at an estimated cost of $250,000, the plant included a main factory building, an office building, a powerhouse, a boiler building, a generator building, and a storeroom. The buildings were built on either side of the rail spur. (Courtesy of the City of Sumner.)

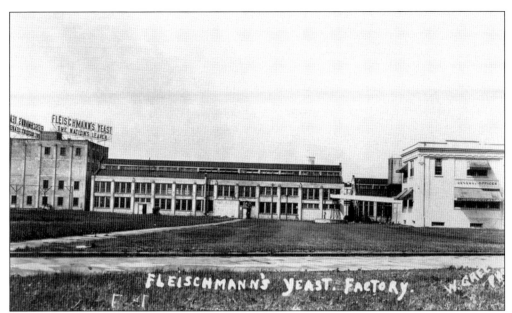

The Fleischmann's Yeast Company buildings were a combination of steel framing and "Denison hollow interlocking blocks" manufactured in nearby Tacoma. Additional structures were added to those completed in the first phase of construction. In 1915, a dry house was added at a cost of $8,000. Eventually, construction costs totaled approximately $500,000. The field near the administration building served as a baseball field for the entire town. (Courtesy of the Spartan Agency, LLC/Sumner Historical Society.)

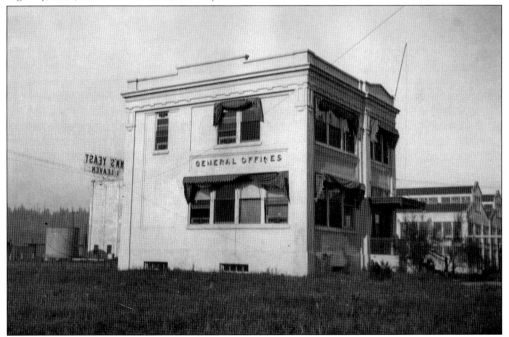

The Fleischmann's administration building was a two-story affair constructed of poured-in-place concrete. From here, managers oversaw an operation that employed as many as 75 workers. This building was demolished in 2009. (Courtesy of the City of Sumner.)

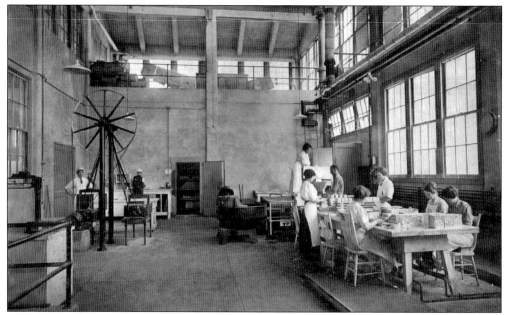

A group of workers—mostly women—are pictured in the cutting and wrapping department inside Fleischmann's Yeast plant, likely soon after the plant began operations in 1913. Although a few electric lights are available, the work table is set up near large windows to provide better illumination. The men—the only ones identified on the photograph—are, from left to right, Dick Gorkman, Eric Johnson (with back turned) and George Adams. (Courtesy of the City of Sumner.)

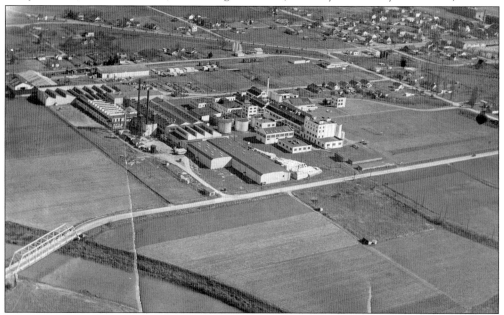

Seen from the air around 1940, the Fleischmann's Yeast Company plant (right of the twin tanks) was nestled next to the Fiberboard operation (characterized by its "sawtooth" roofs). Fryer Avenue is in the foreground. The old baseball field is to the right of the plant. The company announced the closing of the plant in December 1994. Today, a small portion of the remaining buildings are used in vinegar production. (Courtesy of the City of Sumner.)

In 1929, Fleischmann's Yeast Company was merged into Standard Brands Inc. Seen here working at Standard Brands' Fleischmann's plant in 1949 is N.O. Johnson, who had been employed by Fleischmann's for 36 years. Johnson arrived in Sumner in 1912 with a marine engineer's license and spent one year at sea before settling down in Sumner to work as a machinist at the plant. (Courtesy of the Tacoma Public Library, *Sunday Tacoma Times* 25 Year Club.)

The aerial view below shows the Fiberboard Corporation plant, located immediately north of downtown in a growing industrial area that also included the Fleischmann's yeast plant. The corrugated-box plant has operated in Sumner since 1920 and was sold to Louisiana-Pacific Corporation in 1978. (Courtesy of the Tacoma Public Library, Richards Studio Collection.)

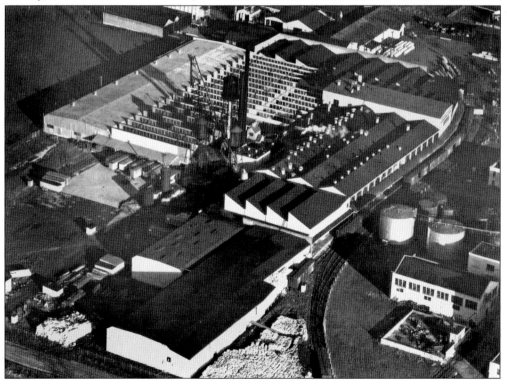

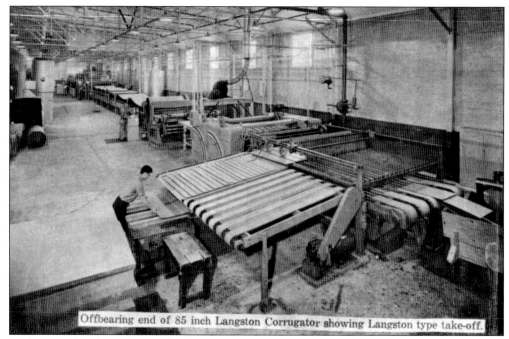

Offbearing end of 85 inch Langston Corrugator showing Langston type take-off.

Built in 1915 as the W.R. Prideham Company, the large cardboard plant next to Fleischmann's was taken over by the Fiberboard Corporation in 1927. In this photograph from November 1952, recently installed machinery produces cardboard for boxes. (Photograph by *Sumner News-Index*, courtesy of Robert Barnum.)

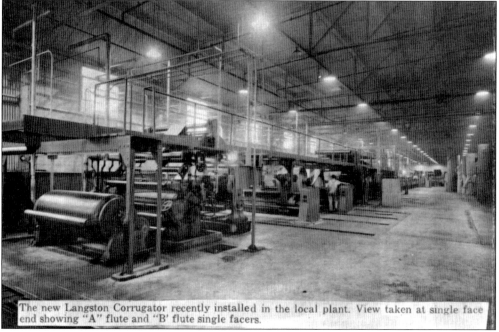

The new Langston Corrugator recently installed in the local plant. View taken at single face end showing "A" flute and "B' flute single facers.

A new Langston Corrugator was installed in the Fiberboard plant in 1952. The clean, modern facility is still in operation today, producing material for use in boxing everything from Hawaiian pineapple to Alaskan salmon. (Photograph by *Sumner News-Index*, courtesy of Robert Barnum.)

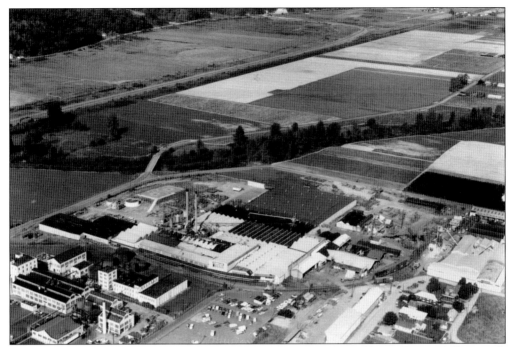

Fleischmann's Yeast Company and the Fiberboard Corporation were neighbors. This aerial photograph from around 1950 was taken from over downtown looking northwest. The Fleischmann's Yeast Company plant is in the extreme lower left, and Fiberboard Company occupies the lower center. In the background, the Milwaukee Road rail line splits the farmland beyond. In less than 50 years, this farm area was converted to industrial buildings. (Courtesy of the Tacoma Public Library.)

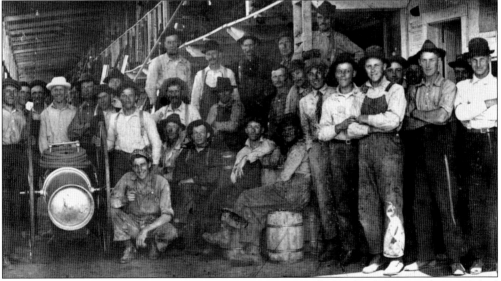

Workers at the Hewitt-Lea-Funck Company (H-L-F) line up for this undated photograph. Established in 1914, H-L-F was purchased by Pacific Lumber Agency in 1922, which specialized in Sitka spruce lumber for use in airplanes. After becoming the Willard Young Company in 1938, the plant began supplying wooden parts for automobiles as well. The plant was in the industrial area near Fleischmann's Yeast Company. (Courtesy of Carolyn Pasquier.)

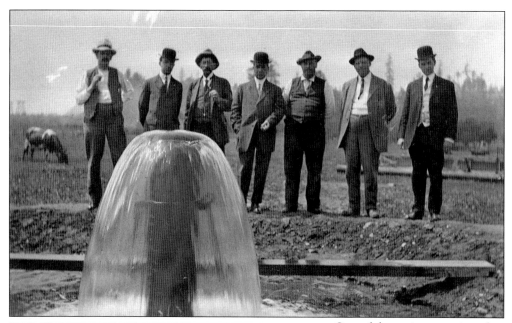

One of the main attractions for Fleishmann's Yeast Company to build in Sumner was the artesian well pictured here, located on the property. The force of the water from underground is pushing it out of this pipe by itself. Posing with the well in 1912 are, from left to right, E.J. Young, Harry Henke, Henry Bower, Fred Clark, Henry Huff, W.S. Huntington, and L.D. Howe. (Courtesy of the City of Sumner.)

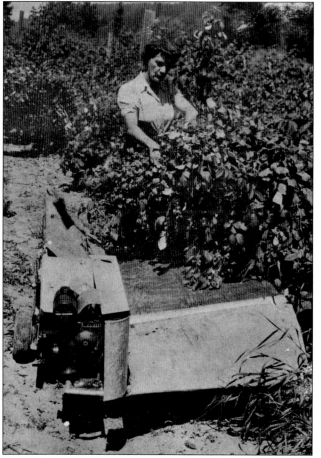

Farming was also a major industry in and around Sumner. In this photograph from July 1953, Mrs. E.J. Fischer works behind a raspberry-picking machine on a farm in the north end of Sumner. Berries were a big industry, as were hops (before the blight), daffodils, and, of course, rhubarb. (Photograph by Sumner News-Index, courtesy of Robert Barnum.)

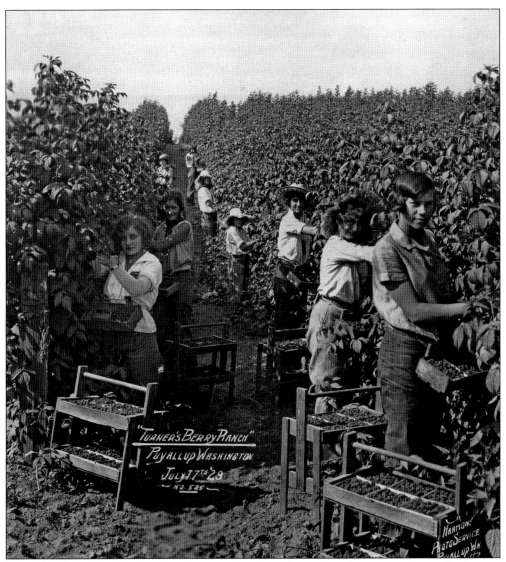

Noted on this 1929 photograph as being in Puyallup, Turner Ranch was actually much closer to Sumner, across the Puyallup River from Sumner in the area now bordered by East Main Street and Shaw Road. Owned by Ed Orton, the "ranch" was run by the Beadell family from 1915 to 1929. Local girls are seen here picking berries on July 17, 1929. Note the incredible height of the berry bushes. (Photograph by Harmon Photograph Service, courtesy of Sharon Guyette.)

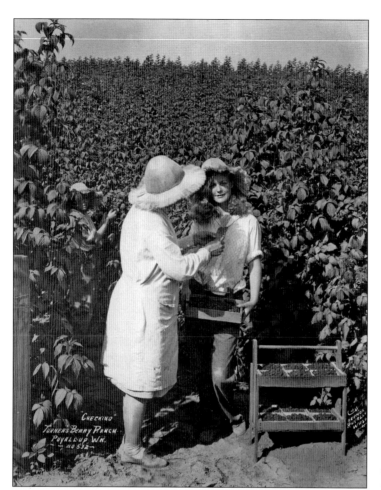

Checking
Turners Berry Ranch
Puyallup, Wn.
No 532

At left, Cora Beadell checks a picker's tag at Turner Ranch in 1929. The individual pickers' tags were punched to indicate how much they had picked and thus how much pay was due to them. Lucille Merritt put the tag below in her scrapbook after working at Orton Farms in 1920. These tags were printed by Nifty Printing on Sumner's Main Street and were retained as a tracking system well into the 1900s. (Left, photograph by Harmon Photograph Service, courtesy of Sharon Guyette; below, courtesy of Sumner School District.)

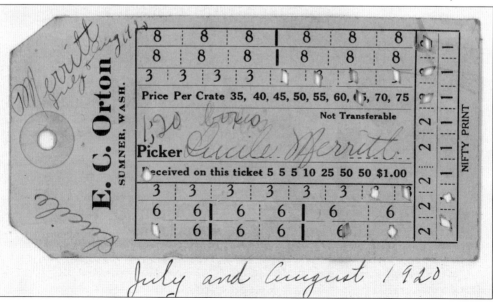

July and August 1920

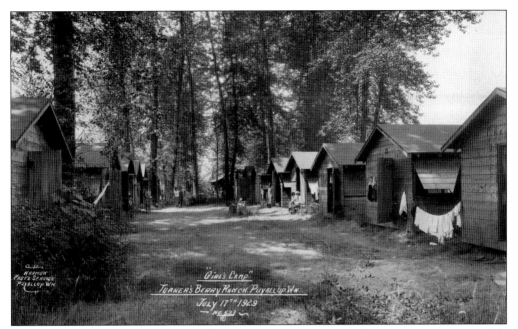

Seen here is the girls' camp at Turner's Ranch, where approximately 70 young women stayed while picking raspberries. The Beadells oversaw the girls, who slept and ate at the camp in the 1920s. It was similar to the more familiar logging camps for men. (Photograph by Harmon Photograph Service, courtesy of Sharon Guyette.)

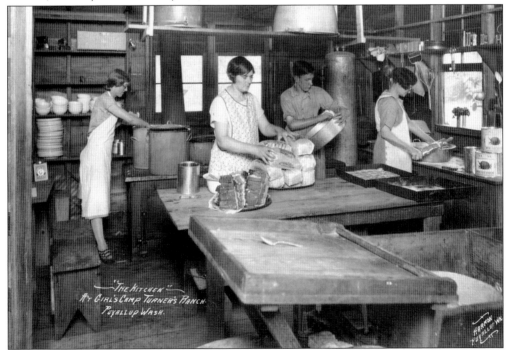

Because the girls' camp housed girls for days, it also featured a kitchen and a cooking crew, seen here. Note the basic kitchen facilities of the time, which served over 70 people at one time. (Photograph by Harmon Photograph Service, courtesy of Sharon Guyette.)

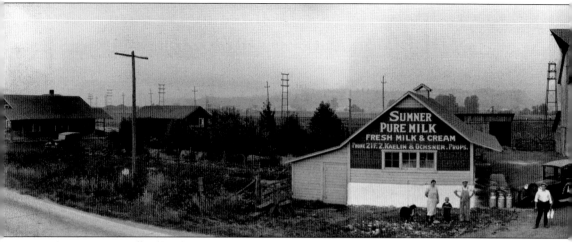

Sumner Pure Milk offered fresh milk and cream from this dairy, located along East Valley Highway near Salmon Creek. The road is actually straight, but the panoramic camera angle creates the appearance of a curve. The 1925 photograph shows, from left to right, Adele Trutman and her son Joey, Gustor Frechs, and proprietors Fred Kaelin and Isidor Ochsner. In 1927, Kaelin moved away

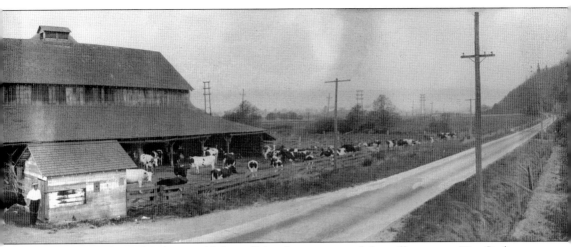

from Sumner, so he and Ochsner sold the milk bottling center and the milk routes to Tim Corliss and Roy Alexander for $2,000. That business was rolled into Alexander's Sumner Jersey Dairy, which later became part of Quality Ice Cream Company of Puyallup. Ochsner kept the dairy and provided milk for Tacoma Milk Producers, and, later, Darigold. (Courtesy of Charles Ochsner.)

Caroline Barnum poses on the family farm in front of crates for berries. Her parents, George and Dorothy, farmed on 142nd Avenue, north of the Ota farm. In the Pacific Northwest, crates like these were used to pick and haul berries. Individual boxes fit inside the wooden crates. The smaller boxes were originally made of cedar, and, later, of cardboard. (Courtesy of Robert Barnum.)

Farming was not without its hazards. The two barns below were built on one side of the West Valley Highway; however, a mudslide pushed both of them, as well as the power poles and other debris, clear across the highway to a stop on the other side, as seen here. Later on, Mosby Farms was located in this area. (Courtesy of Robert Barnum.)

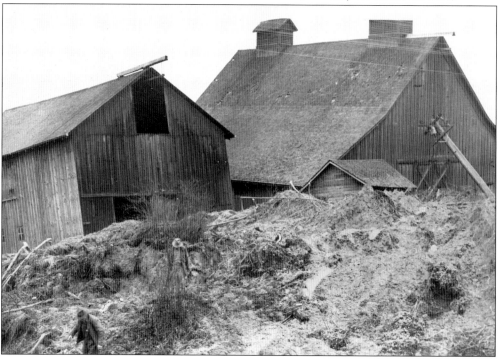

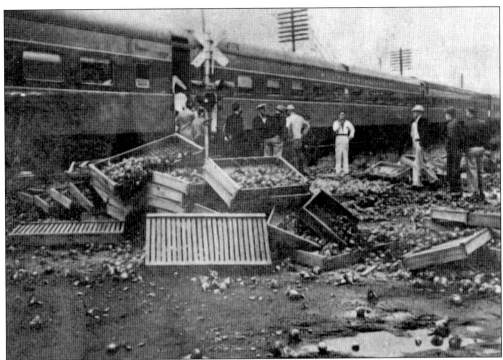

Farm activity sometimes conflicted with the faster world. In September 1953, a bulb truck owned by C.W. Orton was clipped by the Northern Pacific's No. 407 passenger train at a Sumner crossing. Bulbs were strewn widely (above), but the truck (below) seems relatively undamaged. In the postwar era, passenger trains were numerous in the area, with dozens passing through Sumner every day. This level of passenger service soon ended, however. (Both photographs by *Sumner News-Index*, courtesy of Robert Barnum.)

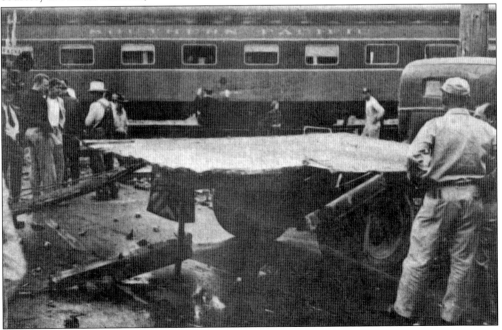

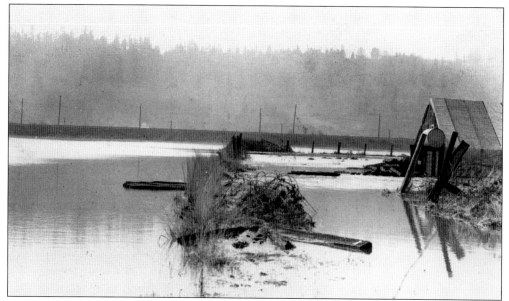

Both the Puyallup and White Rivers were known to periodically leave their banks, and Hazel Freehe recalled a time when the valley was flooded from one side to the other. The Barnum family farm, off 142nd Avenue north of the Ota farm, is seen here after a major flood. The farm grew rhubarb and berries, and the berry posts are just visible above the floodwaters. (Courtesy of Robert Barnum.)

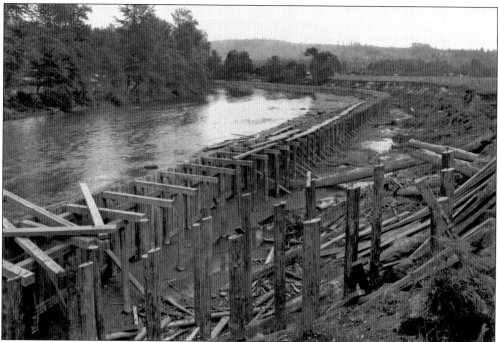

Floodwaters caused heavy damage in the Sumner area in the winter of 1933–1934. Foreshadowing a struggle that continues today, wooden bulkheads were constructed as barriers to prevent future floods. This photograph from May 13, 1934, appears to have been taken along the Puyallup River on the south edge of Sumner. (Courtesy of the Tacoma Public Library, *Tacoma Sunday Ledger*.)

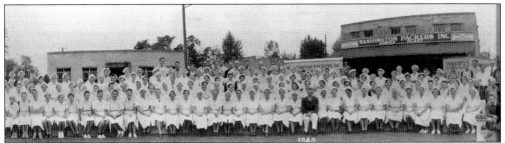

Cora Piper donated this photograph to The Old Cannery Furniture Warehouse, where her husband, Tom, worked from 1940 to 1983. Since 1984, the building has served as a furniture store and gathering place on the west side of the White River. Prior to that, it was an actual cannery, as seen here in 1940 when it was the Sumner plant for Washington Packers Inc. A newspaper article shows that the cannery was sold in 1921 for $115,000. At the time, it was the H.A. Baker Cannery. Regardless of its name, the cannery has been a central figure in Sumner's history for years. (Photograph by Cora Piper, courtesy of The Old Cannery Furniture Warehouse.)

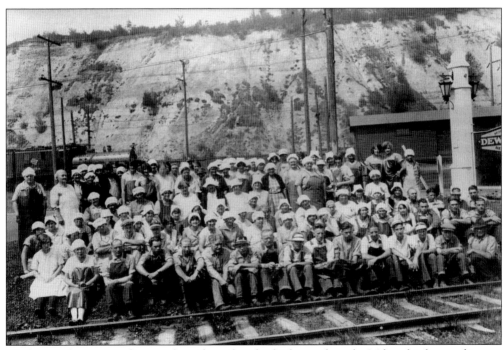

Workers at the cannery line up along the railroad, which was then the Milwaukie line and is now the Union Pacific. The white lamp pole to the right still stands. Horns would sound when workers were needed. When women at home heard the call, they put on their uniforms, which had to be spotless white, and hurried to work. (Courtesy of The Old Cannery Furniture Warehouse.)

Farmers would drop off loads of produce in front of the cannery for processing. In this photograph, piles of beans await processing. During Prohibition, vagrants were attracted to another product of canning; they were often found in the shed by the river enjoying the fermented fruit, as it was the closest thing to alcohol available to them. (Courtesy of The Old Cannery Furniture Warehouse.)

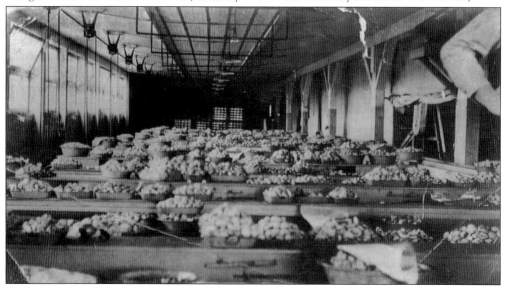

A note on the back of this photograph of the interior of the cannery reads, "This is where I worked just after I got back home. I made $.50 an hour all the time I worked there. We live a block from there. Sumner Cannery, Paulhamus." Longtime residents remember when everyone used to work at the cannery, even soldiers from Fort Lewis. (Courtesy of The Old Cannery Furniture Warehouse.)

Three

RHUBARB PIE CAPITAL OF THE WORLD

Known today as the Rhubarb Pie Capital of the World, Sumner's history is closely tied to the tart red stalk. In 1893, Adam Knoblauch shipped the first field rhubarb to Seattle in gunnysacks. Knoblauch's son Henry was the first grower of commercial hothouse rhubarb in the Sumner area.

Other early rhubarb growers included Charles Orton, Jacob Stelling, Warren and Charles Ryan, Fred Mattson, J.A. Forehand, and Bill McClane. In 1919, the Leslie Brothers started their rhubarb farm in the valley. The family continues to grow rhubarb today and is known as Leslie & Son.

Many of the farmers were of Japanese descent, and, during World War II, several were sent to internment camps. Their neighbors rented out their farms and kept them going in their absence. At the end of the war, some Japanese families chose not to return, but many did come back to take up their farms again. After the war, farmers of Japanese descent took their rhubarb to one of the two growers' associations, the Puget Sound Vegetable Growers.

It was during this time that the Sumner Rhubarb Growers Association also increased its national visibility. In 1957, the two associations took their first step toward working together when they combined their promotions and marketing into the Washington Rhubarb Growers Association. However, they still maintained separate organizations for many more years.

Finally, in late 1974, the two associations merged completely into the Washington Rhubarb Growers Association. At that time, less than 60 remained of the Puget Sound growers, and they were mostly growing rhubarb. Min Terada had served as their manager since 1958. The association's directors were Tom Shigeo (president), Mike Ota, Frank Komoto, Joe Nishimoto, Min Uchida, George Yamamoto, Joe Clerget, and George Kawasaki.

Today, the association has only a handful of farmers left, and the rhubarb now travels by trucks rather than by train, as it did for many years. However, families like the Leslies are still growing and farming rhubarb, and the majority of the rhubarb in the country is still grown around Sumner in the Puyallup Valley.

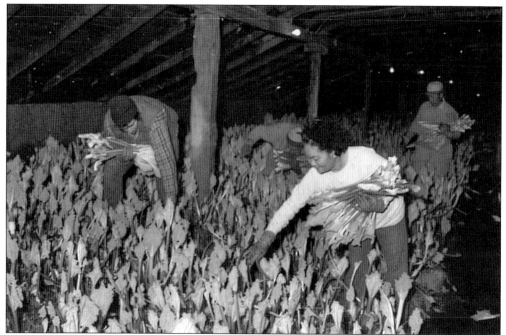

Workers on the Ota farm pull hothouse rhubarb. Hothouses grew rhubarb with red stalks and short, pale leaves through the early winter months, making the hothouse an important tool to help Sumner farmers provide the first rhubarb to the lucrative Eastern markets. Stacy Ota's job as a child was to make sure the heat was on all through the night. (Photograph by Barton L. Attebery, courtesy of the Ota family.)

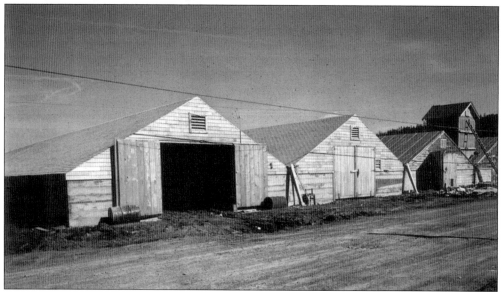

The Ota farm hothouses are seen here. Hothouse farming in Sumner began early in the 1900s. Henry Knoblauch saw smoke coming from a root shack of an old German farmer named Bill Dodson. Knoblauch wondered if Dodson was smoking salmon but found out that he was forcing rhubarb. After, Knoblauch went home and built a 12-foot-by-24-foot hothouse on his farm on Wahl Road. (Photograph by Barton L. Attebery, courtesy of the Ota family.)

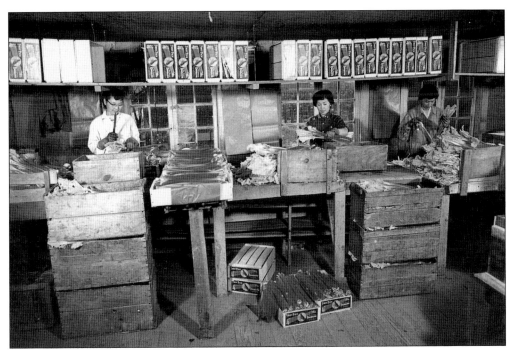

Inside the Ota farm's sheds, women take the rhubarb from large boxes, cut them to a standard size, and pack them in crates for shipping. This image shows both the boxes of rhubarb from the field or hothouse and the crates with the commercial labels on them. (Courtesy of the Ota family.)

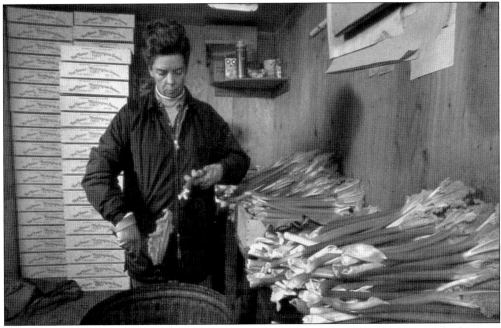

This close-up view shows the same process. Rhubarb leaves are mildly poisonous, which is one reason for their removal before shipping. Leaves on field rhubarb are famously deep green and broad, while hothouse rhubarb has much smaller, paler green leaves. (Photograph by Barton L. Attebery, courtesy of the Ota family.)

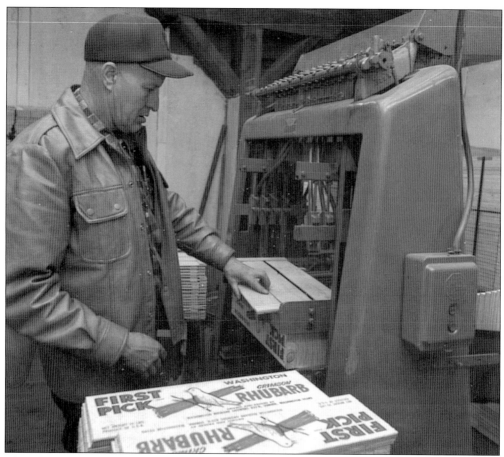

The Rhubarb Growers Association had its own machine to build crates for holding and shipping rhubarb. Stacy Ota recalls building over 1,000 crates each evening after school in preparation for the next day's harvest. On April 10, 1976, a devastating fire swept through the Washington Rhubarb Growers Association, destroying the crate machine and other things. On the back of the partially burned crate label below, the growers wrote an inventory of what was destroyed. They also noted how other people across the state helped the growers recover so that none of their field crop was lost. (Above, photograph by Barton L. Attebery, courtesy of the Ota family; below, courtesy of the Washington Rhubarb Growers Association.)

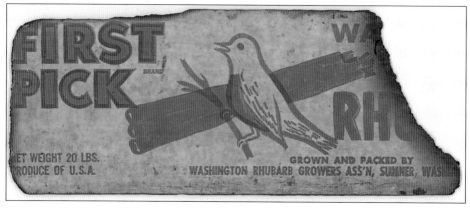

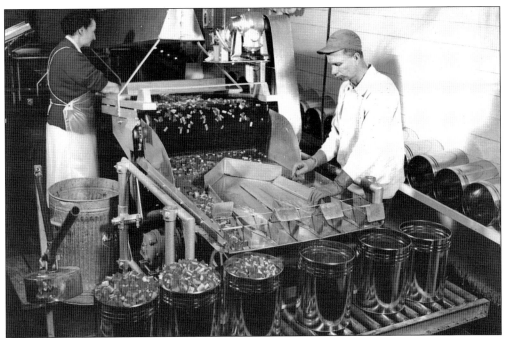

In the 1960s, some rhubarb was sent about 30 miles north of Sumner to be canned in a warehouse in Seattle's Georgetown neighborhood. The rhubarb was sealed in these cans with a lot of sugar for sale and shipment. This facility is no longer there. (Photograph by Barton L. Attebery, courtesy of the Ota family.)

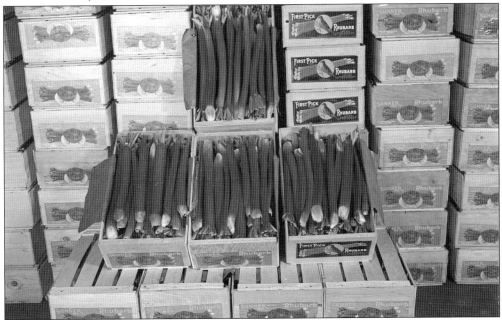

Sumner's fresh rhubarb is seen here trimmed and neatly filled in crates for shipments and sale. There were three grades of packed rhubarb: Extra Fancy, Fancy, and Choice (C Grade). Only stalks of the highest Fancy grade are packed for the fresh market. Any stalks not deemed of this quality are processed instead. (Photograph by Barton L. Attebery, courtesy of the Ota family.)

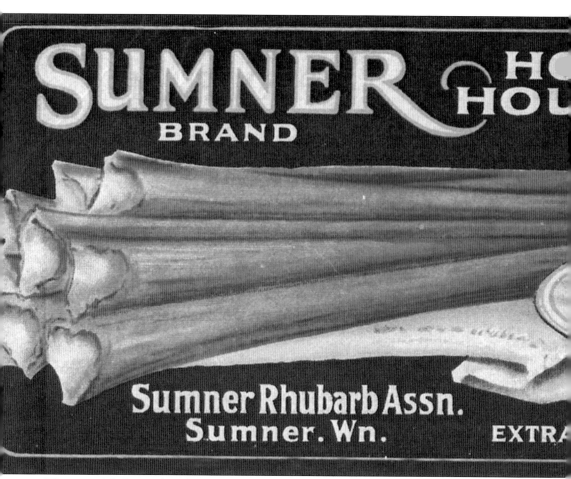

SUMNER
BRAND

Sumner Rhubarb Assn.
Sumner. Wn.

HO
HOU

EXTRA

This crate label served as the front of an invitation when the Sumner Chamber of Commerce dedicated Sumner's new bulb and rhubarb warehouse on January 10, 1931. The new warehouse was built by both the Sumner Rhubarb Growers Association and the Puget Sound Bulb Exchange.

In 1931 alone, they expected to ship 25 to 30 railcars of bulbs plus 110 cars of hothouse rhubarb and 25 cars of field rhubarb. (Courtesy of Whistle Stop Antiques.)

Al Leslie (right) and his young son Ron bring the first rhubarb to market with manager Amiel Goettsch (left) and Bill McClane, the director of the Sumner Rhubarb Growers Association. It was the association that actively promoted Sumner's rhubarb across the country and likely started the claim of "Rhubarb Pie Capital of the World" in the 1930s or 1940s. Goettsch took over as manager of the association in 1948. (Courtesy of Hazel Freehe.)

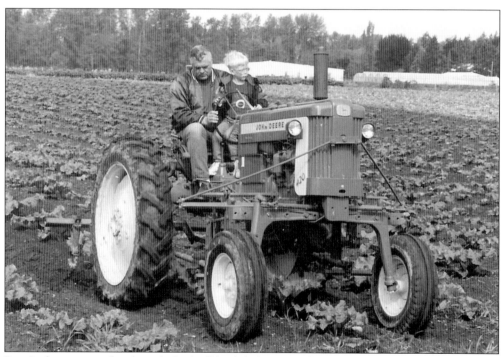

Ron Leslie continued to farm rhubarb all his life; he is seen here working a field with his son Nik in the 1970s. Nik recently took over Leslie & Son as the fifth generation of rhubarb farmers in the valley just south of Sumner. Leslies first began farming in 1919, nearly 100 years ago. (Courtesy of the Leslie family.)

George Richter (left) was an independent rhubarb farmer when the association suggested he join them and promote all of their rhubarb. He began as the sales manager in 1956 or 1957. Hazel Freehe (right) married Clayton Knoblauch, who followed in the footsteps of his father, Henry. Clayton served as the association's president in 1963–1964. When he died in 1965, Hazel ran the farm by herself. (Courtesy of Hazel Freehe.)

No one knows why the claim to fame includes "pie" as well as rhubarb. Perhaps it was simply because Sumner loved pie—lots of different pies—as much as rhubarb. Here, Rotary president George Carnahan (left) and Roy Scott, the chair of the Rotary pie booth, sample blueberry pie. Rotary used the Methodist church to bake blueberry pies to sell as a fundraiser. Today, the tradition continues with the Rotary Pie Booth at the Sumner Arts Festival, which features both rhubarb and berry pies. (Photograph by *Sumner Gazette*, courtesy of Robert Barnum.)

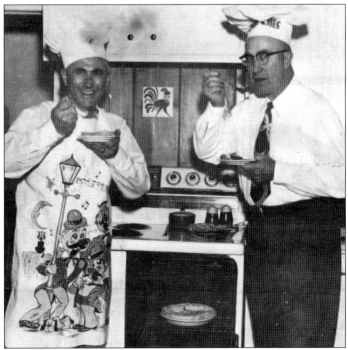

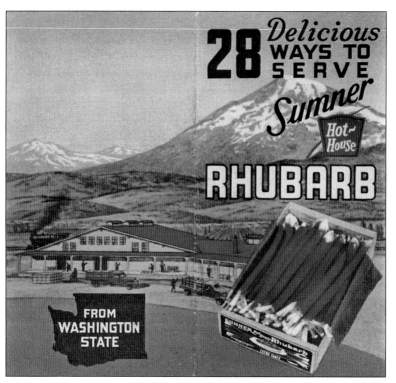

28 *Delicious* WAYS TO SERVE
Sumner Hot~House

RHUBARB

FROM WASHINGTON STATE

The Rhubarb Growers Association compiled recipe books to promote the use and sale of rhubarb. Sales managers like George Richter distributed books like this one across the country at state fairs. This cover from the 1950s shows a rather idealized vision of the warehouse, with the same crate label that was used for its dedication in 1931. (Courtesy of Karl and Barbara Keck.)

This updated recipe book from the 1960s shows the graphic styles changing with the times, although the recipes stayed much the same. The Washington Rhubarb Growers Association still promotes recipes in a further updated recipe book. It also shares its recipes online through the city's website. (Courtesy of Donna Hardtke.)

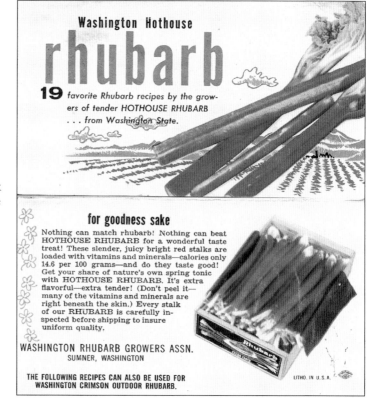

Washington Hothouse

rhubarb

19 favorite Rhubarb recipes by the growers of tender HOTHOUSE RHUBARB . . . from Washington State.

for goodness sake

Nothing can match rhubarb! Nothing can beat HOTHOUSE RHUBARB for a wonderful taste treat! These slender, juicy bright red stalks are loaded with vitamins and minerals—calories only 14.6 per 100 grams—and do they taste good! Get your share of nature's own spring tonic with HOTHOUSE RHUBARB. It's extra flavorful—extra tender! (Don't peel it—many of the vitamins and minerals are right beneath the skin.) Every stalk of our RHUBARB is carefully inspected before shipping to insure uniform quality.

WASHINGTON RHUBARB GROWERS ASSN.
SUMNER, WASHINGTON

THE FOLLOWING RECIPES CAN ALSO BE USED FOR WASHINGTON CRIMSON OUTDOOR RHUBARB.

LITHO. IN U.S.A.

Four

A Classic
Main Street USA

Sumner's earliest businesses clustered along Main Street, an east-to-west arterial route. As periodic fires destroyed the early wood-frame structures, they were replaced by brick buildings one or two stories in height. A particularly devastating fire in 1895 leveled a large portion of the downtown. The core downtown area is still characterized by the brick buildings built from the years just after this fire and on into the early 1900s. The bulk of downtown remains oriented along Main Street, just as it was in the 1870s. Although the business district has expanded eastward over the years, the core area has remained largely unchanged for decades.

Like most small towns, the downtown attempted to provide for all the essential needs of a community not nearly as mobile as today's society. In the first several decades of the 1900s, new businesses were started and existing ones failed at a breakneck rate. Newspaper articles report 20 new businesses opening, a dozen failing, and another half-dozen relocating in a typical year between 1900 and the Great Depression of the 1930s. The fast pace returned after the Depression, with nearly 30 such transactions occurring in 1937.

At any one time during this period, downtown featured six to eight restaurants and four or five service stations. A busy bus service operated out of the "bus building," at Main Street and Ryan Avenue. Passenger trains stopped several times a day at the Northern Pacific station, located near the intersection of Maple Street and the tracks. Photographs reveal automobile traffic on par with that seen today. In some ways, the pace in Sumner's downtown has slowed a little, but it remains the core of the community and a viable business district.

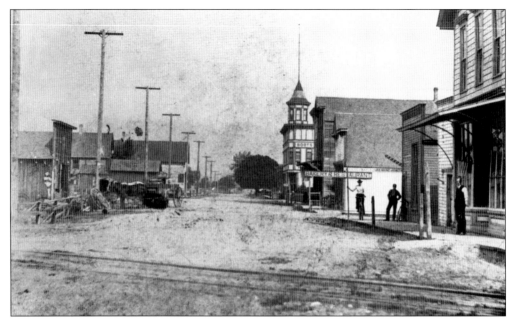

This 1898 photograph looks east down Main Street from just beyond the Northern Pacific railroad tracks. It shows a dusty street and several wood-frame buildings, including the imposing Shipley Building, in the background with its round tower. The distinctive butternut tree by the Ryan House can also be seen in the background. (Courtesy of Hammermaster Law Offices/Sumner Historical Society.)

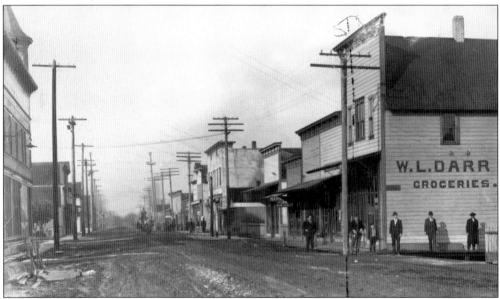

Looking west on Main Street around 1907, this photograph shows W.L. Darr's grocery store, on the corner of Ryan Avenue and Main Street, and the Shipley Building, on the left, at the corner of Alder and Main Streets. Darr had many different versions of his grocery stores, including a later version with partner Frank Kelley, seen on the following pages. Farther down Main Street on the right is the two-story bank building, which was built at 1101 Main Street in 1903 and still stands today. (Courtesy of Spartan Agency, LLC/Sumner Historical Society.)

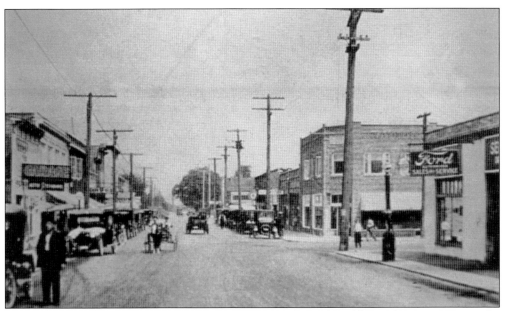

This 1923 photograph looking east along Main Street shows the additional construction in the downtown, including more substantial brick buildings that were more fire-resistant. With its distinctive corner door, the Leverenz Building (right) was built in 1922 and remains today at the corner of Main Street and Cherry Avenue. When it first opened, it housed an optometrist, a dry goods store, and a men's store owned by W.L. Leverenz called The Toggery. The Ford dealership on the right is also visible. (Photograph by *Sumner News-Index*, courtesy of Karl and Barbara Keck.)

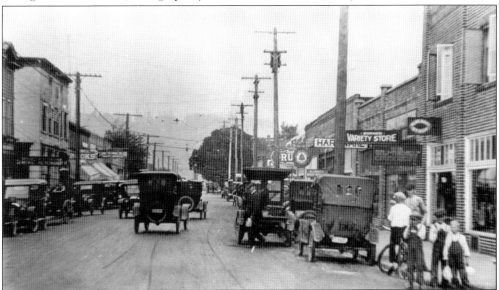

As the 1920s progressed, automobile traffic on Main Street increased. Note that the large butternut tree still stands at the Ryan House in the distance, and helps orient the changes on this photograph from the same view in 1898. Along the right side of the street, the signs advertise the Help-Yourself Grocery, which opened in 1922, Sumner Variety Store, the hardware store, Sumner Meat Market, the telephone company, and Rexall Drugs, which would later become Berens Drugs. (Courtesy of Hammermaster Law Offices/Sumner Historical Society.)

Two men and a dog enjoy Sumner's streets in front of J.J. Hocking's Department Store. This photograph was taken sometime after 1911, when Hocking bought his brother Roswell's interest in the store and changed the name from Hocking Brothers. Although the location is not specified, the photograph appears to be looking down Cherry Avenue and Kincaid Street from Main Street, putting the store where Heritage Park now stands. (Courtesy of Spartan Agency, LLC/Sumner Historical Society.)

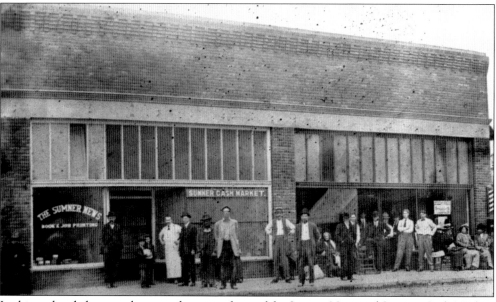

In this undated photograph, a crowd poses in front of the *Sumner News* and Sumner Cash Market, which shared a building at 1105–1107 Main Street. The *Sumner News-Index* started in 1900. The Sumner Cash Market closed on Alder Street in 1906 due to lack of business, but reappeared on business listings by 1913 and moved in 1914 from Narrow Street to the "new building next to the bank," which is likely the building seen here. (Photograph by *Sumner News-Index*, courtesy of Karl and Barbara Keck.)

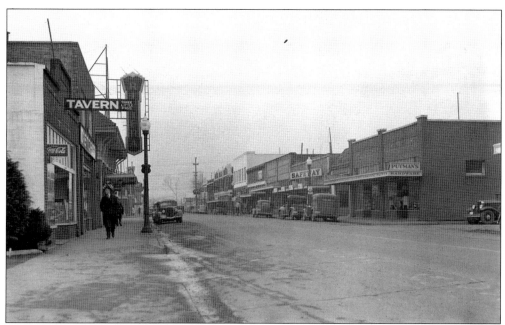

Looking west along Main Street from Ryan Avenue in January 1940, this photograph shows the Three Little Pigs Tavern, the Riviera Theater, Putman's Hardware, and the Sumner Safeway, among others. When standing at the corner of Main Street and Ryan Avenue today, the view on the north side of Main Street is still very much the same. Businesses have changed over the years, but the rooflines remain the same. (Courtesy of the Tacoma Public Library, Richards Studio Collection.)

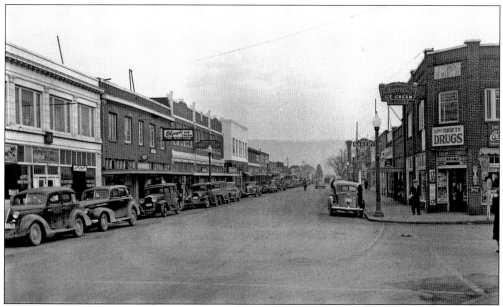

Looking east along Main Street, perhaps on the same January morning as the photograph above, this image shows the Leverenz Building, Beaver's Thrifty Drugs, Klontz Market, Usher's Bakery, The Mint Club, Schafer's Variety Store, and other businesses. (Courtesy of the Tacoma Public Library, Richards Studio Collection.)

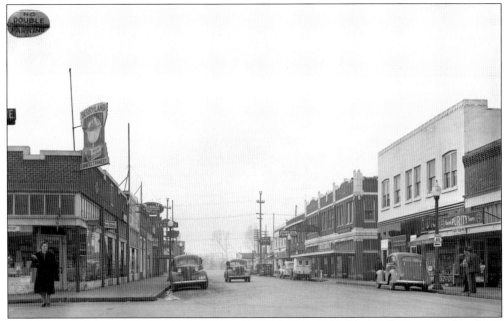

Also taken around 1940, this view westward along Main Street highlights the Berryland Cafe, on the left, Rexall Drugs just visible beyond the cafe, and Purity Market on the right. Although there are many more images of the Berryland in this location, none capture this fanciful sign, which highlights the cafe's reliance on ice cream and candy sales. Note the "No Double Parking" sign in the top left corner. (Courtesy of the Tacoma Public Library, Richards Studio Collection.)

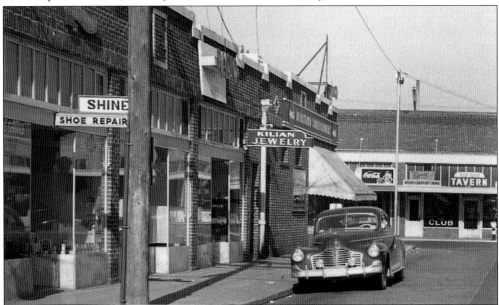

By 1949, a drive north along Alder Street toward Main Street would have gone past Shine Shoe Repair and Kilian Jewelry. On the corner of Alder and Main Street is the Berryland Cafe. This row of buildings no longer exists. In the background, across Main Street, is the same building shown on page 52 in the 1910s, although the *Sumner News* and Sumner Cash Market have been replaced by a food store and tavern. (Photograph by *Sumner News-Index*, courtesy of Karl and Barbara Keck.)

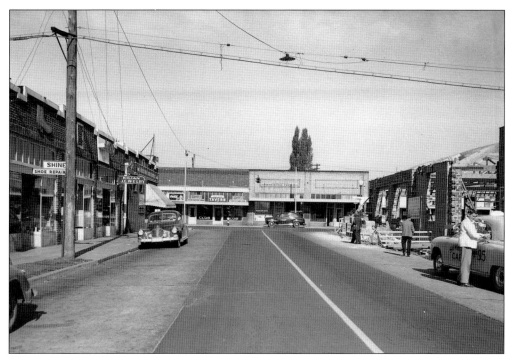

Taken the same day as the previous photograph, this wider shot shows a building on the right under construction. On the former site of the Shipley Building and the Standard Oil gas station, this new building housed Berens Drugs and the bank. It is still standing today. (Photograph by *Sumner News-Index*, courtesy of Karl and Barbara Keck.)

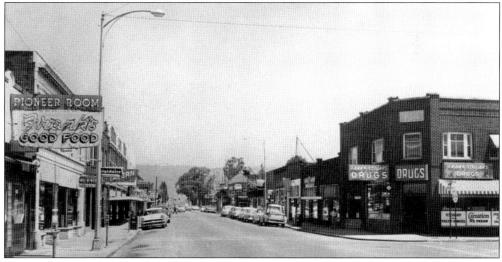

By the 1950s, Sumner's modern downtown was a busy place. In 1947, Frank Sollars bought out Beaver's Thrifty Drugs and renamed it Frank Sollars Drugs, as seen here in the Leverenz Building. Farther down the street, Geter's hardware store is visible, as is the Riviera Theater and the butternut tree at the Ryan House. On the left is Frank's Good Food, which replaced the Valley Cafe, and Gino's Frigidaire. (Photograph by *Sumner News-Index*, courtesy of Karl and Barbara Keck.)

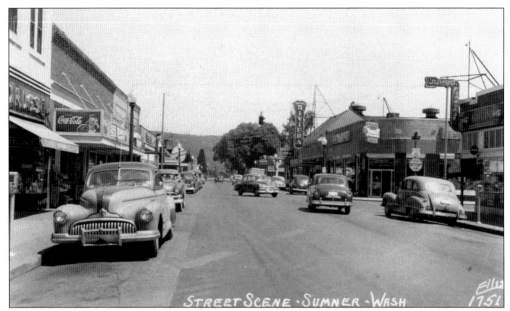

A look east down Main Street in the 1950s reveals a full-service downtown that includes several restaurants, Berens Drugs and the Riviera Theater on the right, and the Thriftway Supermarket down the street on the left. Berryland Cafe's confectionery sign is now replaced with a more modern sign highlighting jumbo hamburgers (right). The stop sign on the right also indicates that by this time Main Street was Highway 410. (Photograph by *Sumner News-Index*, courtesy of Karl and Barbara Keck.)

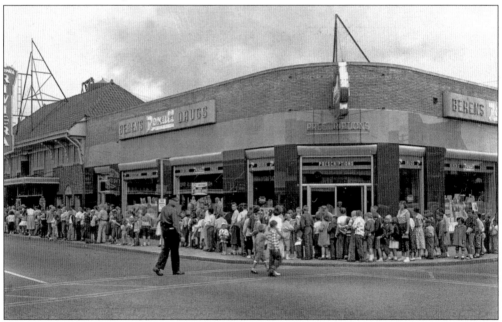

Families line up to buy movie tickets in the mid-1950s. By the end of the 20th century, this scene had changed significantly. The bank expanded into the Berens Drugs space and the Riviera Theater was demolished in the 1970s to create a parking lot and the bank drive-through lane. (Courtesy of J. Larson.)

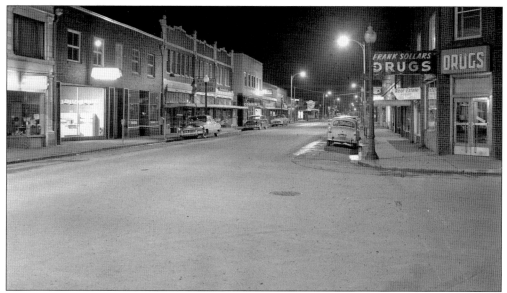

Looking east from the corner of Main Street and Kincaid Avenue, this nighttime scene from the early 1950s shows Frank Sollars Drugs, Sumner 5 and 10 in the Masonic building, and Corbin Fountain Lunch (upper center). (Photograph by *Sumner News-Index*, courtesy of Karl and Barbara Keck.)

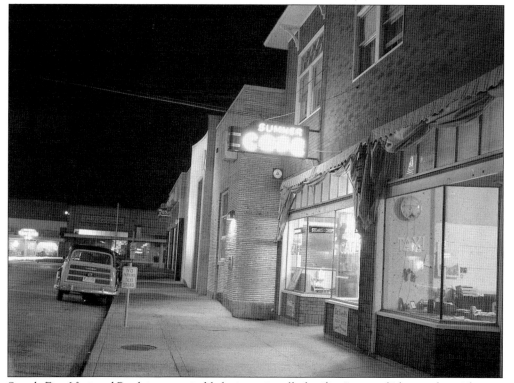

Seattle First National Bank is recognizable by its regionally familiar "scooped" face in this nighttime scene along Alder Street from the 1950s. In the foreground, Sumner Taxi and the Sumner Cafe share the hotel building. Berens Drugs is on the corner of Main and Alder Streets. (Photograph by *Sumner News-Index*, courtesy of Karl and Barbara Keck.)

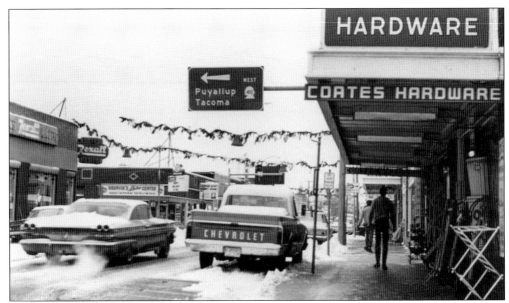

Sumner's Main Street used to be Highway 410, as seen here. When the state made 410 a freeway in 1968, they wanted to follow the same route, but Sumner leaders forced the state to move the freeway to the south end of town, thus preserving downtown Sumner. This snowy scene from the late 1960s also shows Coates Hardware, at 1119 Main Street. (Courtesy of Spartan Agency, LLC/ Sumner Historical Society.)

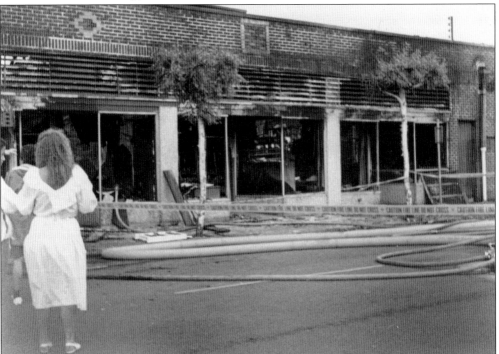

Although the Berryland Cafe had long since moved out, a fire in 1993 finally took the distinctive building that had housed it for so many years on the corner of Main and Alder Streets. At the time of the fire, the building was home to a Mexican restaurant. (Courtesy of Ernie Trujillo.)

Five

THE CHANGING FACE OF BUSINESS

Since very early in its history, Sumner has had a wide spectrum of business activity. The very earliest commercial endeavors were those typical in other parts of the Pacific Northwest: lumbering and agriculture. Even those activities were pursued in wider variety in Sumner than in many neighboring areas. Agriculture, in particular, saw landowners planting hops, flower bulbs, and rhubarb alongside more traditional crops.

By the 1890s, an active business center had developed along Main Street. An imaginary stroll down Main Street by pioneer and author Amy M. Ryan in her 1965 book *The Sumner Story* noted a vigorous business center with three blacksmiths shops, a harness shop, a general mercantile, a pharmacy, a livery stable, three groceries, a hotel, a jewelry store, a bakery, a hair salon, a meat market, a shoemaker, and a hardware store. For many years, Sumner was a dry town, explaining why no saloons are mentioned in Ryan's tour down Main Street. In 1918, Goodwin Pharmacy, on Narrow Street, was closed by the "dry squad for illegal operations in liquor," according to the *Sumner News-Index.*

Over the next few decades, additional Main Street business were joined by an industrial area featuring businesses such as the Fleischmann's Yeast Company plant, the Fiberboard Corporation, and Hewitt-Lee-Funk, makers of bakers' yeast, cardboard, and specialty wood products, respectively. Today, a vibrant downtown supports an industrial area to the north that is a regional center for warehousing and manufacturing of nearly every type.

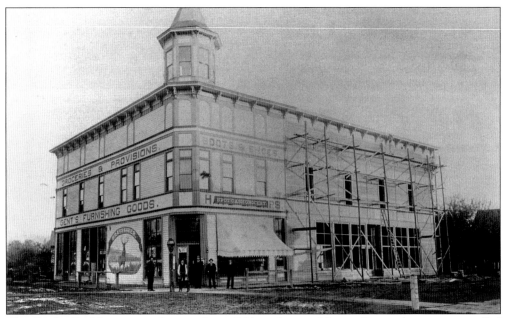

The Shipley Building is seen here with scaffolding for an addition. Sumner's newspaper called it "one of Sumner's most pretentious business buildings." Standing at the corner of Main and Alder Streets, which was later the site of a drugstore and a bank, this building housed a lot of businesses, including Bray & Baker Hardware & Notions, Darr & Kelley grocery, W.H. Ingalls shoe and harness shop, the Hotel Best, and the office of Dr. J.H. Corliss. The building burned in August 1914. (Courtesy of Hammermaster Law Offices/Sumner Historical Society.)

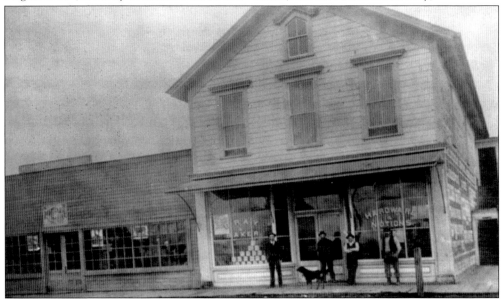

This early image of Bray & Baker Hardware & Notions shows a downtown Sumner business before sidewalks, wires, or paved streets. Bray & Baker appears in listings of Sumner businesses back to 1900. The building also housed the Sumner Harness Shop in 1904, Schneider the tailor in 1907, and R.W. Ricketson, a "painter and paperhanger," in 1908. C.A. Myers of Portland finally bought Bray & Baker in 1911. (Courtesy of the City of Sumner/Sumner Historical Society.)

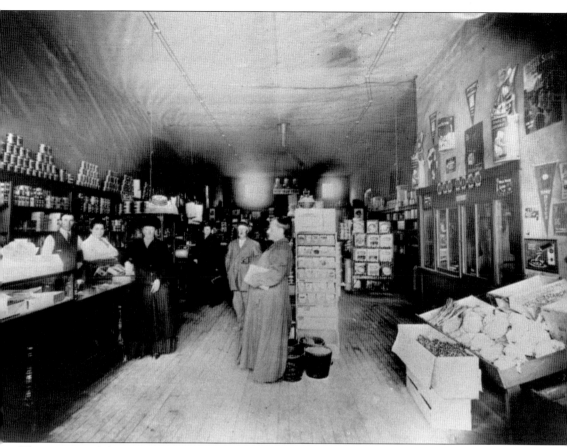

The interior of the Sumner Grocery Company is seen here, likely when it was in the Shipley Building before it burned in 1914. W.L. Darr ran many different kinds of businesses in Sumner before partnering with Frank Kelley in 1913 to operate this store. (Courtesy of Hammermaster Law Offices/Sumner Historical Society.)

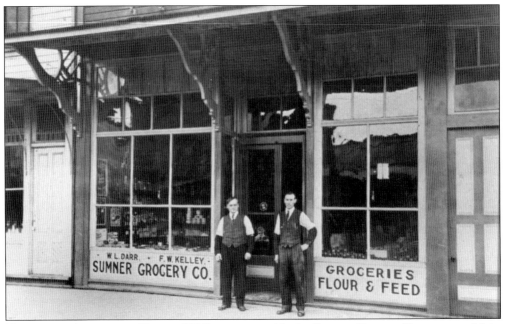

Two men, perhaps owners Darr and Kelley, pose outside the Sumner Grocery Company on Main Street between 1914 and 1916. This image likely shows the second location of the store after the Shipley Building burned in 1914 and before Darr sold his share of the business to Kelley in 1916. (Courtesy of Hammermaster Law Offices/Sumner Historical Society.)

The Sumner post office was originally located on Narrow Street, as seen here in 1901 when Ernest Darr was postmaster. J.P. Stewart helped establish the first post office, which served both the area of Puyallup and Sumner. Stewart called the entire region Franklin. By the time this photograph was taken, Sumner and Puyallup each had its own post office. (Courtesy of Hammermaster Law Offices/Sumner Historical Society.)

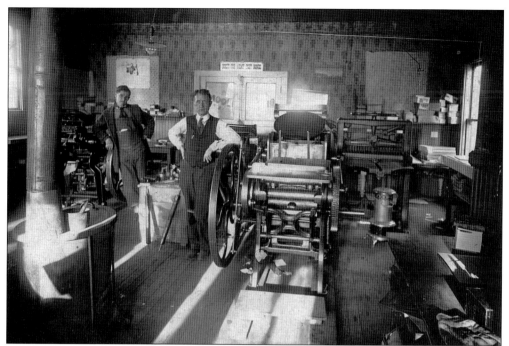

Lee Morris (left) and Corydon Nifty Garrett pose in the Garrett Print Shop around 1910. In later years, the shop became Nifty Printing, which printed the *Sumner News-Index* and other things, including the berry-picking tag on page 30. The building still stands at 1117 Main Street, and "Nifty" is still printed on the floor of the entrance. (Courtesy of Kareen Shanks.)

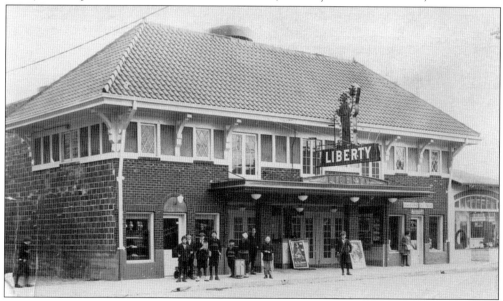

In 1924, Dominic Constanti opened the Liberty Theater on Main Street. The name changed to the Riviera in 1935, meaning that this image was taken sometime between those two dates. In 1936, Mike Barovic took over ownership as a group of five theaters. To the far right are the distinctive arched windows of the Standard Oil gas station on the corner of Alder Street. (Courtesy of Spartan Agency, LLC/Sumner Historical Society.)

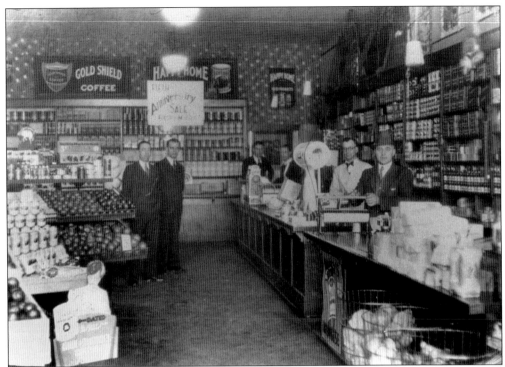

This interior photograph shows the Sumner Grocery Company around 1930. However, by 1926, the Sumner Grocery was sold and replaced with a Piggly Wiggly store, likely in the existing building at 1114 Main Street, which later became Tony Strozyk's Valley Variety. In 1934, this grocery combined with Geiger's Market and moved to Main and North Ryan Streets, later becoming Thriftway. (Courtesy of Hammermaster Law Offices/Sumner Historical Society.)

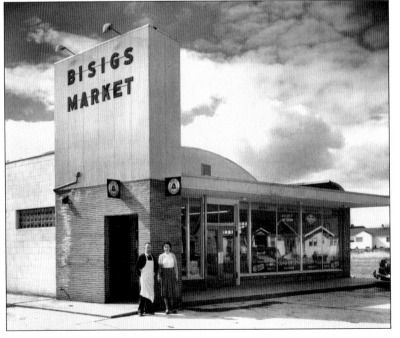

Bisig's Market was located at the intersection of Main Street and Valley Avenue in a building that still stands today. Owners Emil and Rose Bisig are seen here in front of their modern store in March 1949. An emigrant from Switzerland, Bisig was well known for his sausages. (Courtesy of the Tacoma Public Library, Richards Studio Collection.)

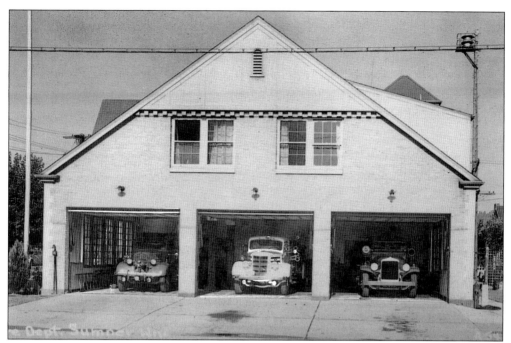

Sumner City Hall was built in 1935, with its three garage doors facing Alder Street to house three of the city's fire engines, including its 1932 Kenworth (far right). Today, those three bays comprise the city council chambers and the courtroom, although you can still see the three bays, which are now windows. The city also still owns the 1932 engine, the first fire engine ever built by the Kenworth Company. (Courtesy of the City of Sumner/Sumner Historical Society.)

Sumner had many pharmacies and drugstores in the early 1900s. In 1927, Art Berens bought the interest of his partner, C.R. Coffman, in the Modern Drug Store, seen here. The store advertised stationery, cigars, candy, and drugs. (Courtesy of Spartan Agency, LLC/ Sumner Historical Society.)

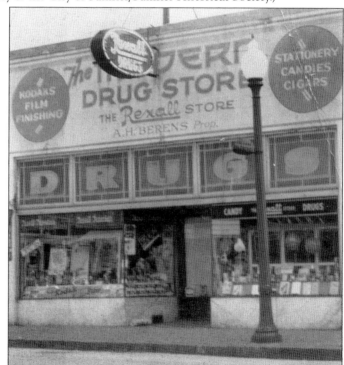

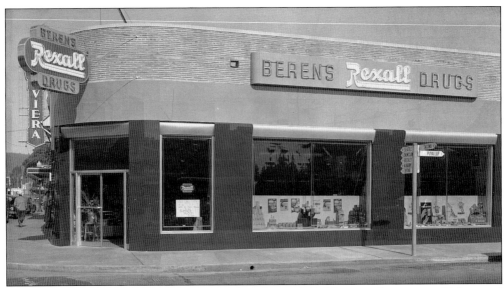

In 1949, the bank and Berens Drugs moved to this new building on the corner of Main and Alder Streets, on the site of the former Shipley Building and the Standard Oil gas station. The construction of this building is seen on page 55. To the right was the bank, which eventually took over the drugstore half as well. Although now covered with a brick front, the distinctive rounded corner is still visible. (Courtesy of Spartan Agency, LLC/Sumner Historical Society.)

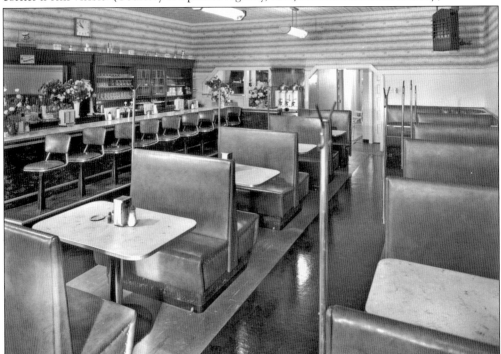

The Valley Cafe is seen here in November 1949 with its modern interior. Al Shinstine and Ruth Murlick opened the cafe in 1948 in the location of the former My Wife Cafe. The building remained a cafe, with many names through the years, before it was burned down by arson in 2005 when it was K.C.'s Caboose. (Courtesy of the Tacoma Public Library, Richards Studio Collection.)

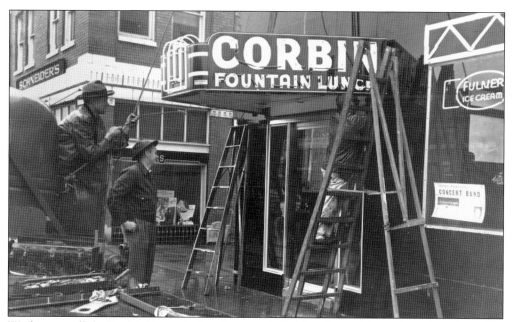

Workers install the Corbin Fountain Lunch sign at 1101 Main Street, likely when the cafe opened in 1949. This building was built in 1903 as a bank, and the vault remains inside today. In the background, Schneider's men's store is visible in the Masonic building, which also still stands today. (Courtesy of Spartan Agency, LLC/Sumner Historical Society.)

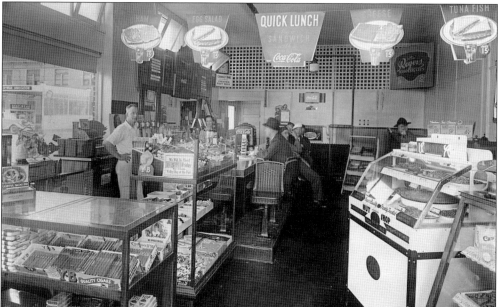

The interior of Corbin Fountain Lunch shows another classic lunch counter, although display cases also show a brisk trade in candy and cigars. After owning the Berryland Cafe for years, Waldo Corbin opened this lunch counter in the old bank building, which had already housed a confectionery and ice cream parlor all the way back in 1913, when Messick & Son opened their store. Today, it is the new home of Berryland Cafe. (Courtesy of Spartan Agency, LLC/Sumner Historical Society.)

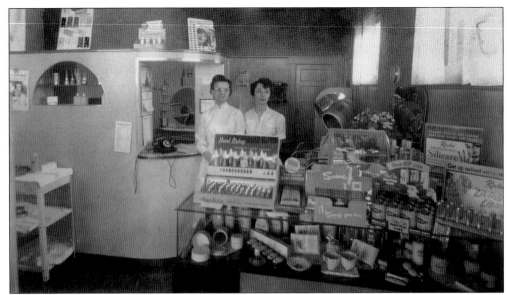

Owner Ellen Prukop (left) and Sylvia pose in 1954 at Charm Beauty Salon. Then located at 919 Ryan Avenue, the salon later moved to 915 Alder Avenue and then to Academy Street before it was sold to Mary Gill in 1968. For National Beauty Salon Week in February, the salon would do the hair of Sumner's older ladies for free. (Courtesy of Beverly Shilling.)

Sumner's working women met as the Business & Professional Association (BPA). This meeting at Corbin Fountain Lunch in February 1958 included, from left to right, Leah Overfield; Ellen Prukop, the owner of Charm Beauty Salon; Estel Burleigh, who worked at Snider's Mercantile; Lois Mercereau, who worked at Coates Hardware; Mildred Woodman, who owned Quality Cleaners; Mary Moser; an unidentified guest; and Juanita Corbin, who owned Corbin Fountain Lunch. (Courtesy of Beverly Shilling.)

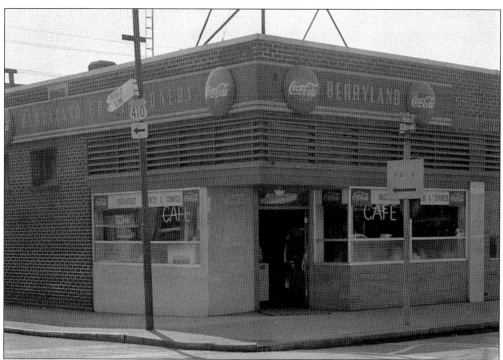

The exterior of Berryland Cafe's Main and Alder Street location is seen above. Berryland began as a confectionery shop in 1926. The Corbins purchased the Berryland Cafe in 1937 and merged it with another ice cream store in 1939 before selling it in 1942. The cafe changed hands many times, but was always a mainstay of the downtown and continues in operation today. (Courtesy of Spartan Agency, LLC/Sumner Historical Society.)

The inside of the Berryland Cafe in the 1950s shows a classic American diner, complete with a counter, Coca-Cola advertisements, and even Lyons Root Beer in the keg to the right. In a newspaper advertisement in 1950, Berryland offered ice cream sodas for 15¢, sundaes for 20¢, hamburgers for 20¢, and coffee for 5¢. (Courtesy of Spartan Agency, LLC/ Sumner Historical Society.)

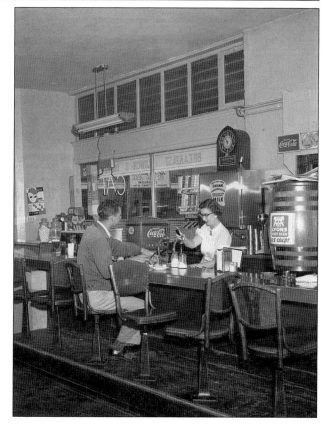

Randy Strozyk (left) and his brother Mike pose for a Christmas promotion in their family's store, Valley Variety. At this point, the store was located at 1114 Main Street, and the family lived above it. Strozyk recalls that year being very exciting, as it included personal visits from Santa Claus. (Courtesy of Randy Strozyk.)

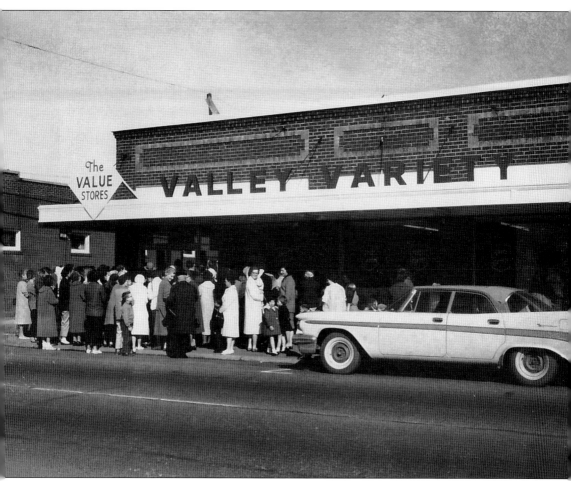

Tony Strozyk's Valley Variety later moved from 1114 Main Street to this larger location at 1201 Main Street. Strozyk used many methods to attract customers, including offering a fish tank with 300 live goldfish on opening day. One year, he trucked in snow for the day-after-Thanksgiving sale. All went well until that evening, when police chief Ron Hyland called Strozyk and told him to remove the snow blocking Main Street. (Courtesy of Randy Strozyk.)

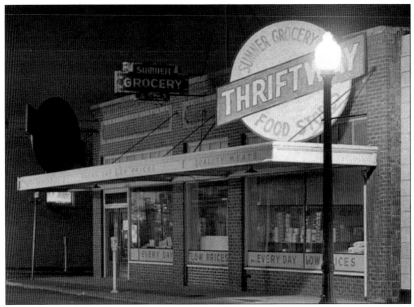

For many years, Thriftway occupied the former Valley Variety location at 1201 Main Street, although the "Sumner Grocery" sign harkens back to a name used by many businesses since 1900. In the 1960s, Thriftway built a modern grocery store at Maple and Alder Streets, which later become a Red Apple market before closing altogether in 2006. This building still stands and continues to house a variety of businesses. (Courtesy of Spartan Agency, LLC/Sumner Historical Society.)

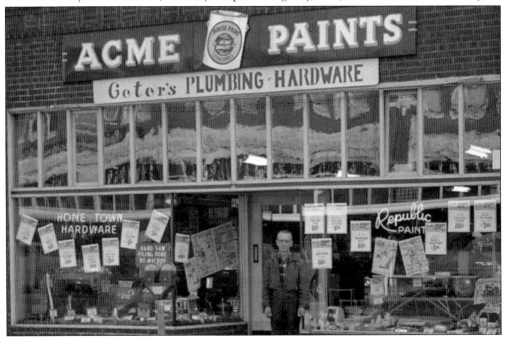

Geter Stokes started in the plumbing business in 1944, and his plumbing and hardware store is seen here at 1006 Main Street. Sumner has enjoyed many hometown hardware stores, from Bray & Bakers around 1900 to McLendon Hardware today. This building now houses a boutique shop. (Courtesy of Spartan Agency, LLC/Sumner Historical Society.)

Six

TRAINS, CARS, AND DRIVING TO THE FUTURE

Transportation has always shaped Sumner. Before settlers arrived, two rivers came together here. In 1853, Sumner pioneers, including William Kincaid, were the first to cross the Naches Pass on their last leg of the Oregon Trail. In 1873, the Northern Pacific announced that it would end its cross-country rail line in Tacoma, putting the line right through Sumner. However, the trains did not intend to stop here, so George Ryan changed their mind with a rather unique strategy: he built a depot at his own expense and paid the salary of the agent for a year. The trains brought new industries to Sumner. Old-timers talk about when they could walk to the Sumner station and take a train to anywhere in the world. In fact, until 1962, all of Sumner's city limits could be reached within a 15-minute walk from the depot.

Sumner changed with the times, though, and horses gradually gave way to cars and buses. Bus lines ran through Sumner in the 1920s, and cars took over Sumner's streets after that. Sunset Chevrolet and Riverside Ford became mainstay businesses in Sumner, as did numerous gas stations up and down Main Street. Sumner billed itself as the "Shortest Way to Rainier National Park," and pointed motorists across the bridge near the cannery and into Sumner.

With the arrival of freeways and highways, Sumner once again became the meeting point where Highway 167 met Highways 410 and 512, with Highway 162 coming up from Orting. Today, trains and buses once again use the same depot site to carry people to Seattle, Tacoma, and beyond. Cars still fill Main Street, although the parking meters and local taxis of the 1950s are gone. Sumner continues to travel out and welcome people in.

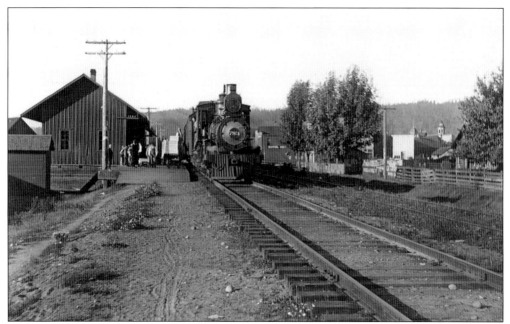

This photograph looks north at Sumner's railroad station, with the cupolas of downtown businesses to the right. The station was roughly where the commuter rail station is today. To get the trains to stop, George Ryan built a depot at his own expense and paid the salary of the agent for a year. He was reimbursed later, and Northern Pacific took over the station. (Courtesy of Spartan Agency, LLC/Sumner Historical Society.)

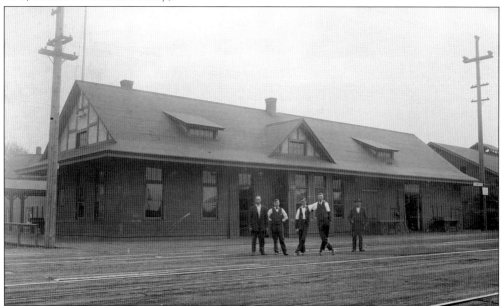

This image shows the Sumner rail station in the 1910s. Lee Morris is third from the left. The signs behind the men advertise Western Union Telegraph and American Railroad Express. People still remember taking the train from Sumner to reach destinations across the country. Today, the area is once again a train station, serving Sound Transit's commuter rail. (Courtesy of Kareen Shanks.)

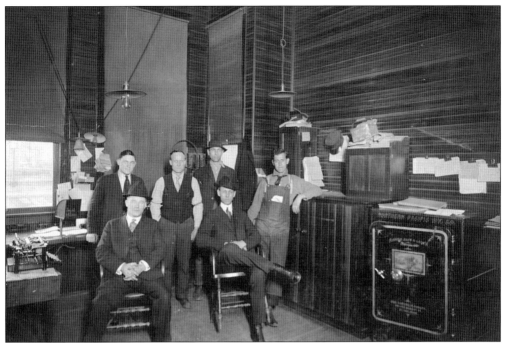

These men gathered inside the Northern Pacific station in Sumner around 1910. Lee Morris is on the far right. Note the early typewriter on the table to the left and the rather imposing safe on the right. Providing more than passenger traffic, the trains stopping in Sumner meant big business. Gary Peterson remembers that the high school football team used to load rhubarb on railcars as part of their conditioning. (Courtesy of Kareen Shanks.)

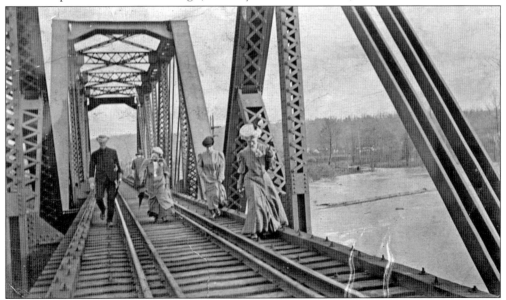

The Puyallup River flooded in 1906, destroying the vehicle and pedestrian bridge. The only remaining crossing from Sumner to Puyallup was this railroad bridge. Seen here from left to right are Frank B Weick Sr., Florence Stevenson, Mae H. Tate, and Miss Dudley. (Courtesy of Ginny Weick Henderson.)

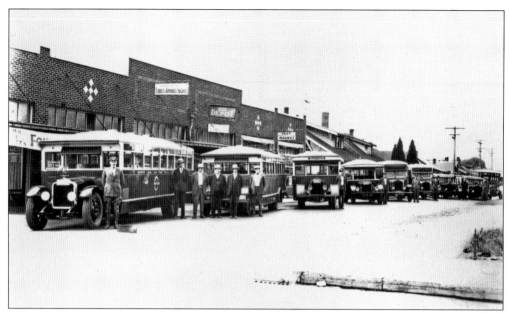

By the 1920s, the Sumner-Tacoma Stage Company's depot, seen here, was on Main Street near Ryan Avenue. Brothers Peter "P.O." and John W. Conlon bought the line in 1921. In 1922, they also bought the Puyallup and Orting bus lines. Seen here from left to right are Pete Gratzer, Frank Conlon, P.O. Conlon, John W. Conlon, Charley Marquardt, and Mac Wilson. The smaller buses served Wilkeson and Carbonado, near Mount Rainier. (Courtesy of the Tacoma Public Library, Jack Conlon collection.)

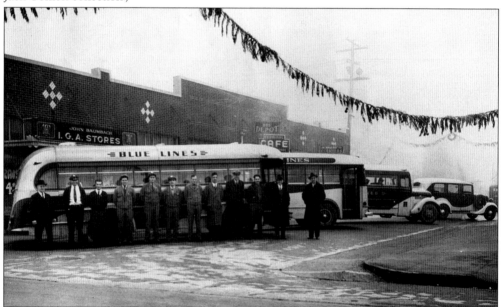

By the 1930s, the stage company had been renamed the Blue Lines. In 1925, the Conlon brothers were also selling Maxwell and Chrysler cars in Sumner. P.O. Conlon sold the bus business in 1939. Seen here from left to right are John Kuss, Bob Parks, unidentified, Bill Gill, Cliff Whitcomb, Moe Wilson, Buster Wilson, Gus Bordson, Ben Lemon, Frank Poch, Peter Conlon, and Ray Tuttle. (Courtesy of the Tacoma Public Library, Jack Conlon collection.)

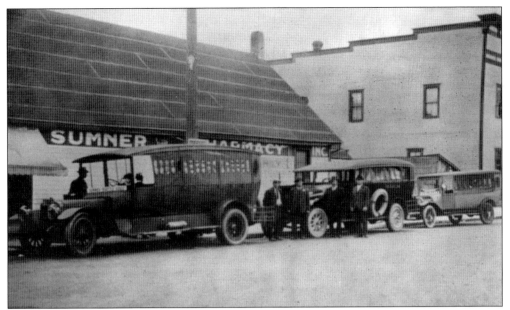

Like every city, Sumner transitioned from horse-drawn vehicles to motor vehicles for transportation. William Hummon started the Sumner-Tacoma Stage Company in 1913 while he ran Sumner's livery stable. Hummon sold the company in 1915 to Charles Buege and C.A. Hanson. In that same year, R.G. Fryar bought W.L. Nasmyth's interest in the Sumner Pharmacy, seen behind the buses in this image. (Courtesy of the City of Sumner/Sumner Historical Society.)

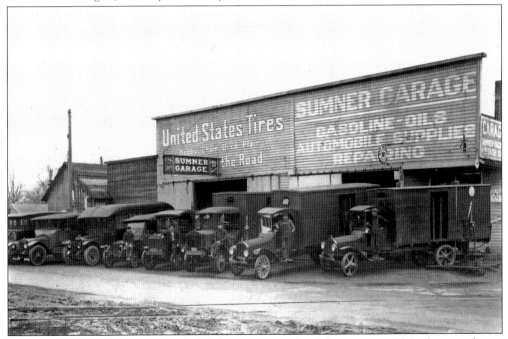

The Sumner Garage was on Pacific Highway, just north of the cannery. This photograph was taken sometime after 1925. The three trucks to the right belong to the Conlon brothers' transfer firm. The Conlons also operated the Sumner-Tacoma Stage Company in the 1920s and 1930s. (Courtesy of the Tacoma Public Library, Jack Conlon collection.)

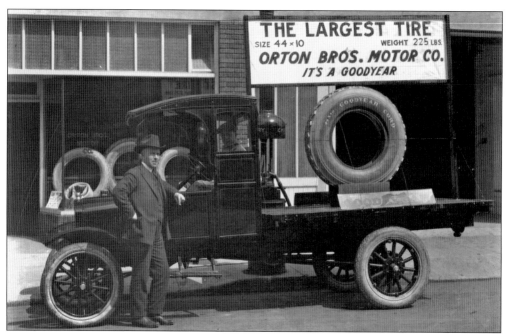

This large tire was on display in front of the Orton Brothers Motor Company on May 3, 1920. The man leaning against the truck is probably one of the Orton brothers. William J. and Charles W. Orton were also in the bulb-growing business. The brothers purchased the Ford agency from a Mr. Cox in 1917 and sold it to "Seattle parties" in 1920, the same year this photograph was taken. (Courtesy of the Tacoma Public Library, Boland collection.)

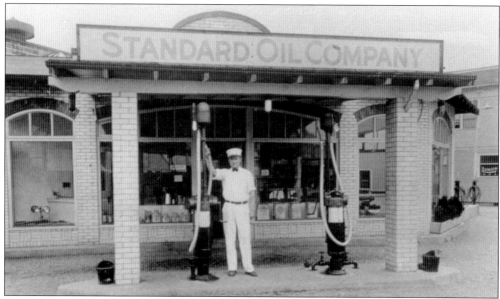

After the Shipley Building on the corner of Main and Alder Streets burned down in 1914, Harry Williams and Herman Wiesner established Sumner Auto Supply on the site in 1919, which was Sumner's first service station. In 1923, Standard Oil bought the station and assigned it as station No. 699. In 1937, Standard Oil sold it to Union Oil, after which it was operated by Harold Slagle until it became a Shell station in 1940. (Courtesy of Spartan Agency, LLC/Sumner Historical Society.)

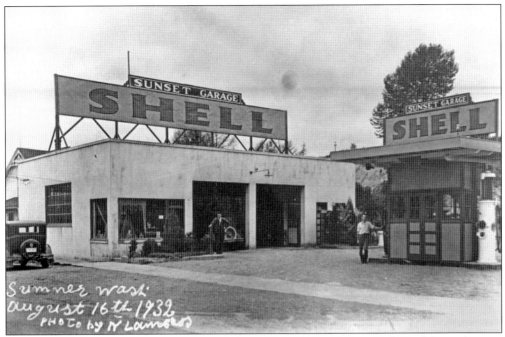

Oz Rogers "began greeting drivers of Chevrolets" in 1927 on Main Street and North Ryan Avenue, as reported in the *Sumner News-Index*. "Later, with the removal of the agency, Mr. Rogers continued the Sunset Garage at that location for awhile and then moved to the garage at the end of the Stuck River bridge," seen here on August 16, 1932. (Courtesy of Mary Sanford.)

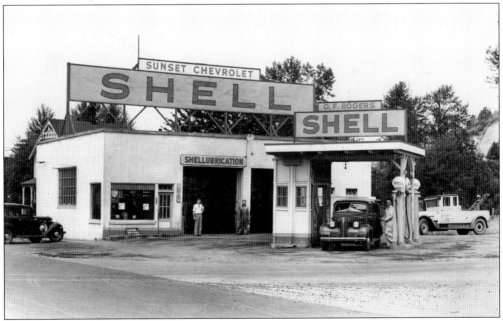

This slightly later image of Oz Rogers's Sunset Garage shows some changes. Note the early tow truck to the right. Rogers moved out in 1940 and the building became Riverside Garage. It still stands at the corner of Traffic Avenue and Main Street. Although it has been remodeled extensively, the shape of its original structure is still visible. (Courtesy of Mary Sanford.)

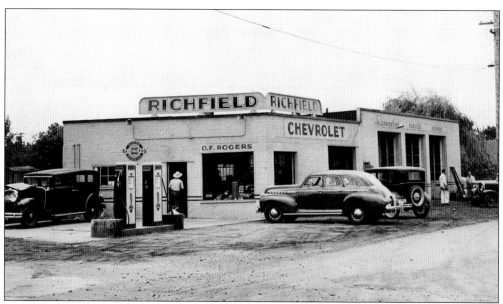

Once Oz Rogers became an authorized Chevrolet dealer again, he needed more room for a showroom and shops. He bought the property at 910 Traffic Avenue, one block south of his garage, and moved there in 1940. Although it is seen here in that same year with the name Richfield, the dealership later returned to its original name of Sunset and continues in operation at this site today. (Courtesy of Mary Sanford.)

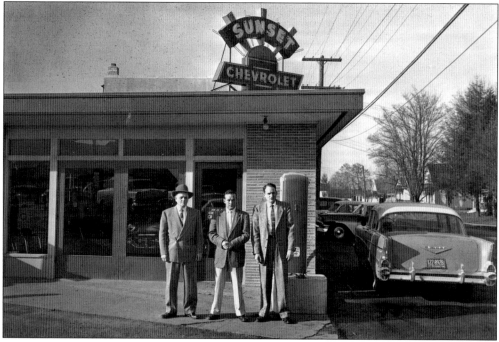

The building was remodeled by the 1950s and became Sunset Chevrolet. Oz Rogers sold the business to Buster Van Horn, who later sold it to Jerry Yoder, who got his start washing cars on the lot in high school. Although extensively remodeled again in 2011, Sunset Chevrolet remains in this same building today. (Courtesy of Mary Sanford.)

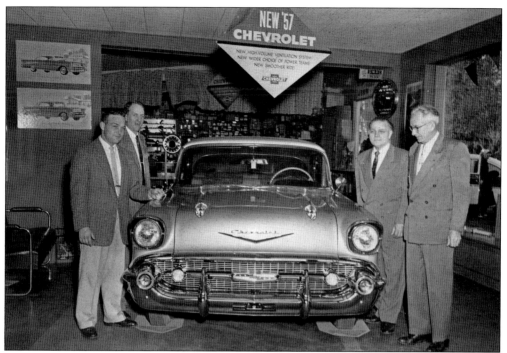

Inside the showroom at Sunset Chevrolet sits a brand new 1957 Chevrolet. The sign boasts of "New high volume ventilation system; new wider choice of power teams; new smoother ride." Through car shows at Sunset Chevrolet and downtown, Sumner continues to celebrate classic cars like these. (Courtesy of Mary Sanford.)

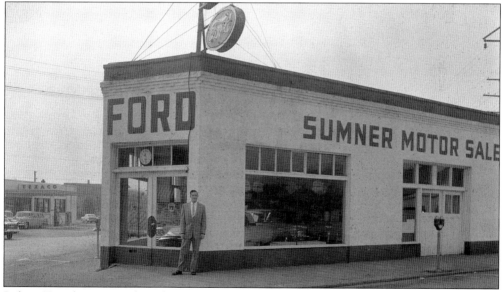

Robert Templeman stands in front of the Ford dealership on Main Street and Cherry Avenue in the late 1950s. Fords were later sold on Traffic Avenue at Riverside Ford before moving in the late 1990s to the 166th Avenue interchange area. This building still stands, and a 2010 remodel returned it closer to this original design. Note Mick Kauth's Texaco station on the left and the parking meter on the right. (Courtesy of Spartan Agency, LLC/Sumner Historical Society.)

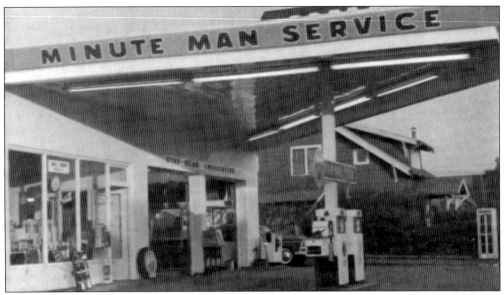

This image from the early 1950s shows Paul Snow's service station, at 1215 Main Street, advertising "Minute Man Service." This image, from an advertisement in the Sumner High School yearbook, shows that very little has changed. The building is currently a tire store and remains nearly the same. (Courtesy of Ernie Trujillo.)

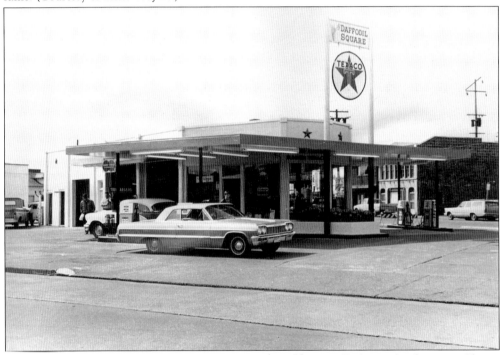

Mick Kauth's Daffodil Square Texaco station sat where Heritage Park is today, between Cherry Avenue and Kincaid Street south of Main Street. This 1963 image shows the station along with the Daffodil Square sign, which Kauth still has and shares with downtown Sumner. To the right are the buildings on Cherry Avenue, which still stand today. (Courtesy of Spartan Agency, LLC/ Sumner Historical Society.)

Seven

SPARTANS' SCHOOL DAYS

Sumner is served primarily by Sumner School District but also by Dieringer School District to the north. In 1924, Sumner superintendent O.K. Glover wrote, "Ignorance furnishes the soil for doctrines of direct action, for futile experiments and for anarchy. Even an elementary knowledge of sociology, economics and government, coupled with habits of reading, would make many disastrous experiments impossible . . . If the public can be induced to do its part, the future usefulness and growth of the Sumner schools is assured, for their task is honorable and great."

Education has always been of great importance to the community of Sumner. In its earliest days, it provided the roots not only for two school districts but also for Whitworth College, which began in Sumner before moving to Tacoma and then Spokane. Perhaps the greatest achievement of Sumner schools is that they are an integral part of the community. From the first school building to the current administration building, grade schools, middle school, and high school, Sumner's schools are prominently located on Main Street. The marching band practices up and down the streets, and, on Friday nights in fall, the lights come on in Sunset Stadium. From plays to community dinners, the schools always have been and remain a central gathering place for the entire community.

These photographs of classes, classrooms, clubs, educational opportunities, student fun, and sports show many familiar names of individuals who went on to be leaders in Sumner and the region. Family names also repeat, as students grow up and have families of their own, sending their children and grandchildren to the same schools they attended.

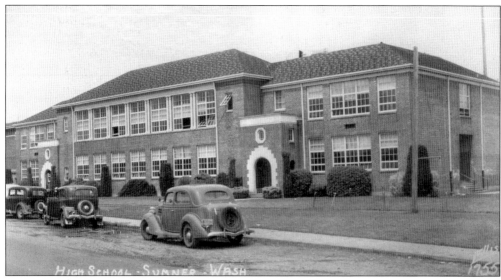

The second Sumner High School was on Main Street, to the west of the current high school building. Students hailed farewell to the first high school in 1920. By the 1950s, today's high school was in use, but the stones etched with "Sumner High School" that are over the arched door in this photograph remain in front of the current school. (Courtesy of the City of Sumner/ Sumner Historical Society.)

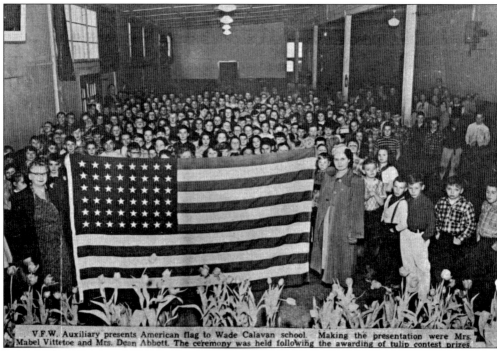

In 1953, the Veterans of Foreign Wars (VFW) Auxiliary presented the American flag to Wade Calavan School. The *Sumner News-Index* reported that Mabel Vittetoe and Mrs. Dean Abbott presented the flag after the school's tulip contest. Today, Sumner's VFW continues to place flags at the markers of veterans in Sumner City Cemetery. (Photograph by *Sumner News-Index*, courtesy of Robert Barnum.)

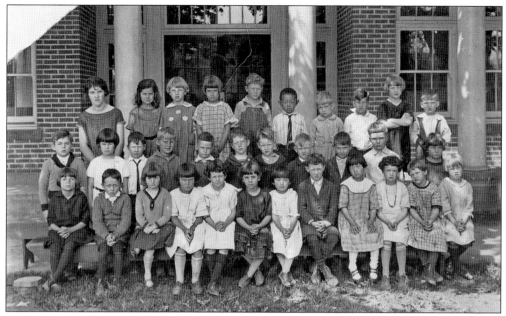

The first grade class poses in 1924 in front of the new Wade Calavan School. From left to right are (first row) Fern Brandt, four unidentified, Marion Knoblauch, unidentified, Walter Moser, Mary Ota, unidentified, May Beyet, and unidentified; (second row) Billy McGowen, Martha Sonneville, two unidentified, Whiting Mitchell, unidentified, Paul Snow, and four unidentified; (third row) a teacher thought to be Ms. Lambert, Elsie Toker, Gladys Ryan, Marjorie Knoblauch, unidentified, Tommy Schigeo, Gertrude ?, and three unidentified. (Courtesy of Martha Sonneville, Sumner School District.)

Sumner is served by two school districts, the Sumner School District and the much smaller Dieringer School District. This photograph shows the first through eighth grades at Dieringer School in 1932. (Courtesy of Martha Sonneville, Sumner School District.)

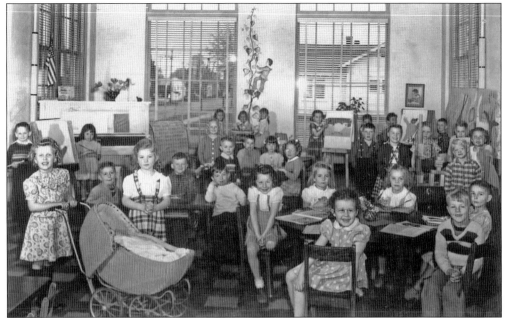

This photograph shows Mrs. Huntington's Kindergarten class at the Wade Calavan School in the early 1950s. Note the distinctive *Jack and the Beanstalk* mural painted on the back wall, as well as the baby buggy and painting easels. North and Sumner Streets are visible through the windows. (Courtesy of Sumner School District.)

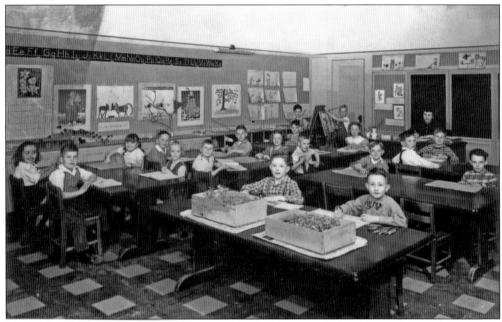

This photograph shows another classroom at Wade Calavan School, located at 1202 Wood Avenue. In the late 1920s, this building replaced the original, grand Sumner School building, which was destroyed by fire in 1924. This building later served as the school district's administration building until it was replaced in 2004 with a new building that echoed the architectural details of its two predecessors. (Courtesy of Sumner School District.)

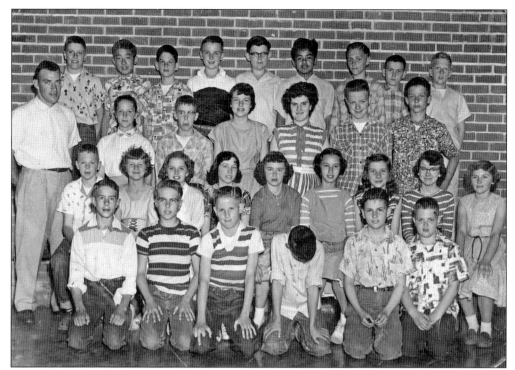

This class photograph from the 1950s includes, in no particular order, Patty Flynn, Pat McGrath, Susan Nigro, David Wise, Charles Mietzner, Larry Curtis, Oren McWilliam, Mike Rabang, Bonnie Barber, Patty Kiehlmeier, Arlene Curtis, Barbara Gerhard, Vincent Rene, Charles Weaver, John Zehnder, Sandra Stromberg, York Bennett, John Wolcott, Ona Hanson, Mike Ota, Karen Collier, Vernon Skeels, Eugene Johnson, Melvin Roger, Albert Shepard, Carolyn Olsen, Ruth Marie Hulet, Jim Turner, Tom Walter Nelson, and Victor H. Wright. (Courtesy of Ernie Trujillo.)

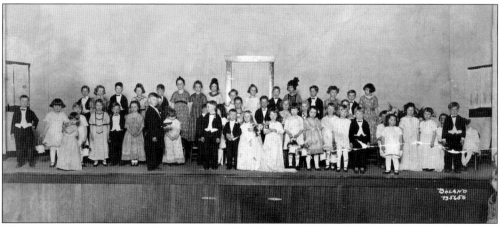

This Sumner grade school play in 1922 shows changing styles, from long dresses that evoke an earlier time to the feathers worn in seven-year-old Polly Weick's hat (back row) and her bobbed hair, indicating the start of the Roaring Twenties. Frank B. Weick Jr., age five, is in the front row on the far left, with his hand on his hip. (Photograph by Boland, courtesy of Ginny Weick Henderson.)

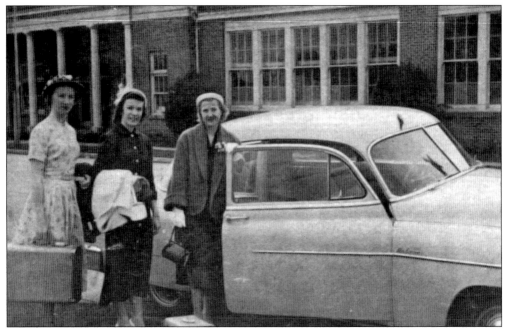

From grade school students playing with baby buggies to high school clubs, schools reflected and prepared students for adult life. This image from the *Sumner News-Index* in 1953 shows students Susan Taylor (left) and Beverly Lind of the Future Homemakers of America Club joining advisor Grace Gilkey to attend a state convention in Ellensburg. (Photograph by *Sumner News-Index*, courtesy of Robert Barnum.)

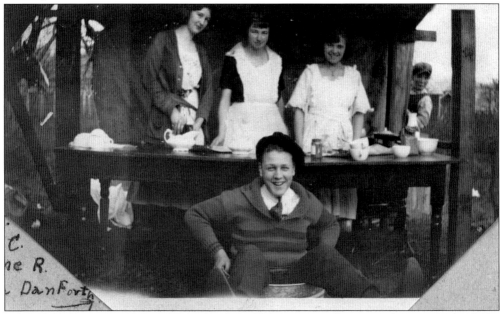

School life also cemented friendships that lasted lifetimes. Lucille Merritt kept a scrapbook she called "My Golden School Days Class Memories" in 1923. She included this candid photograph of (from left to right) Dorothy "Dot" Webb, Maxine Ranney, and Della Danforth, with Glenn "Phat" Carter in front. (Photograph by Lucille Merritt, courtesy of Sumner School District.)

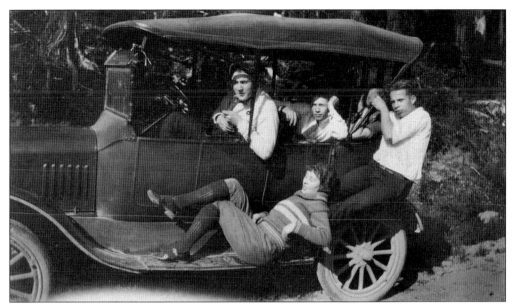

Seniors returned home from Senior Sneak Day on April 25, 1923, after surely creating great memories like the ones seen above. (Photograph by Lucille Merritt, courtesy of Sumner School District.)

This Lucille Merritt photograph captured the fun-loving spirit of her classmates in 1923. Merritt included photographs in and around the high school, at trips to Vashon Island and Green River Gorge, and at games played throughout western Washington. (Photograph by Lucille Merritt, courtesy of Sumner School District.)

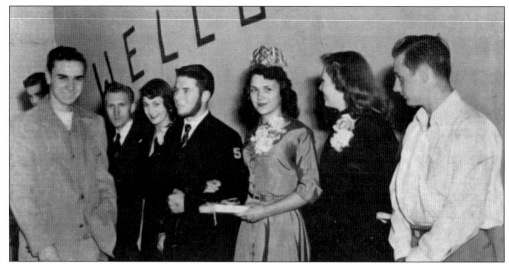

Homecoming has long been an important tradition at Sumner High School. In 1951, Audrey Rouse was crowned homecoming queen. She is seen here with, from left to right, Fred Stump (partially obscured), Dale Wright, Louis Richards, Marilyn Sutherland, Richard Nichols, Audrey Rouse, Eva Beattie, and Wally Sibbert. (Photograph by *Sumner News-Index*, courtesy of Robert Barnum.)

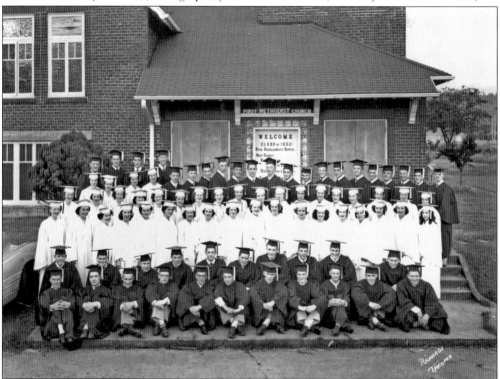

The Sumner High School graduating class of 1950 poses in front of the Methodist church on Wood Avenue, where baccalaureate services where held. The class of 88 seniors received their diplomas during graduation ceremonies in the Sumner High School gymnasium. Orville L. Brown, the chairman of the board of education, presented the diplomas, and principal Arne Strand presented the special awards. (Courtesy of the Tacoma Public Library, Richards Studio Collection.)

The 1960 yearbook highlighted these cheerleaders and noted that " 'Togetherness' was the objective of the 1959–60 yell leaders. They tried hard to cooperate and work together. Queen Mary Ann was ably assisted by Princesses Sandy Ray, Nancy Littlejohn, Marie Foley and Janice Turnbull." (Courtesy of Ernie Trujillo.)

Members of the senior class of 1960 are seen here entering the current Sumner High School. The yearbook noted that in that year, Pres. Dwight D. Eisenhower toured Europe and South America, Hawaii became the 49th state, *Wedding Spells* was the senior play, and the Spartans took second in state class A basketball. (Courtesy of Ernie Trujillo.)

The 12-man Sumner High School football team of 1922 poses with their championship trophy. For the second year, Sumner had won the Pierce County championship, with a 5-1 record, including a victory over Kent High School, as happily noted on the ticket stub below. Its only loss was to Auburn. Sumner defeated Puyallup on November 5 by seven points before a large homecoming crowd. However, the rival high schools tied 7-7 on November 30, leaving the valley championship undecided. Sumner players involved in that game included, from left to right, (first row) Dwight Taylor, George Taylor, William Barron, Dwight Paulhamus (captain), Gerald Reynolds, Dean Taylor, and Paul Benton; (second row) Coach Davis, Hugo Sperling, Ivan Swarthout, Coridan Caster, Clarence Bortle, and Melvin Peterman. (Above, courtesy of the Tacoma Public Library, Boland collection; below, courtesy of Sumner School District.)

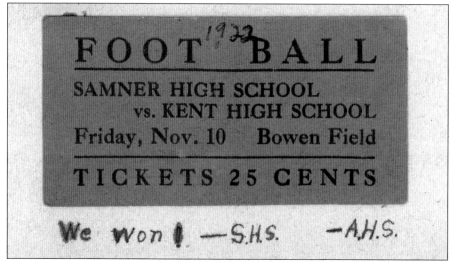

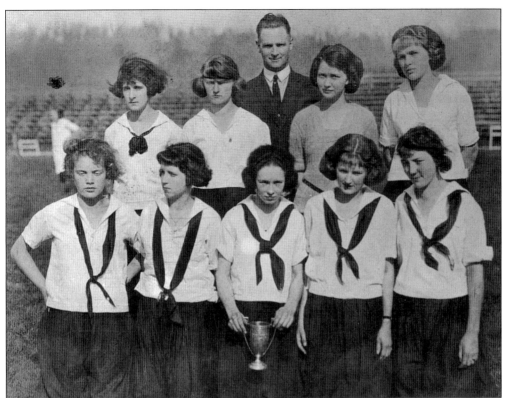

The 1923 Sumner High School girls' track team included, in no particular order, Gladys Caster, Lois Foster, Caroline Barron, Hope Purvis, Dorothy Goss, Helen Merritt, Jean MacLachlan, Doris Darr, and Jewel Powers. The coach, Mr. O.K. Glover, is at back center. By this time, girls played many sports, including basketball, baseball, and tennis. (Photograph by Lucille Merritt, courtesy of Sumner School District.)

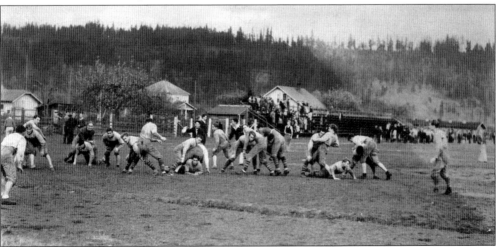

Sumner High School's football team engages in a pregame scrimmage at the school's field in 1933. Frank B. Weick Jr. is on the ground under two teammates but still looking directly at the camera, while the crowd on the sidelines enjoys the show from the bleachers. (Courtesy of Ginny Weick Henderson.)

Football remains a big part of school and community life. This 1960 yearbook photograph shows players leaving the school building to head for a game. From left to right are Walt Winnger, David Wise, Tom Piper, and number 55, unidentified. (Courtesy of Ernie Trujillo.)

Eight

DAFFODIL FESTIVAL BLOOMS

After the hop blight destroyed the hops industry throughout Sumner and the valley, farmers looked for alternate crops. They found winners in berries, rhubarb, and daffodils. In 1930, Sumner had a wrought-iron sign placed at the east entrance of the town that read "Sumner—Bulb Capital of the West." The Sumner Arts Commission refurbished the sign and returned it to its original location at Coryells Corner in 2007.

Sumner was also the birthplace of the greatest celebration of the daffodil industry, the Daffodil Festival. In 1926, the *Seattle Post-Intelligencer* ran a clip that noted, "Betty Jane Orton helped entertain club and society women interested in backing the local bulb industry, at a daffodil tea at her country home, Orton Place, in Sumner, yesterday." Young Betty Jane was about two years old at the time.

On April 6, Mr. and Mrs. Charles Orton hosted civic leaders from 125 cities throughout western Washington, including the mayors of Seattle and Tacoma and Maj. Gen. Robert Alexander, the commander of Fort Lewis. This garden party was timed just right for guests to see the flowers in full bloom, and the party became an annual occasion. By 1932, the celebration became known as Bulb Sunday, but the traffic congestion was so bad in Sumner and other cities that Bulb Sunday did not last long. In 1934, Tacoma photographer Lee Merrill suggested a parade, and the idea took root.

Today, the tradition of a grand floral parade continues. It is one of the longest parades in America, traveling from Tacoma to Puyallup and then through Sumner to Orting, where it ends. The parade was suspended during the war years of 1943–1945, but, except for that, it has been a continuous celebration of daffodils and the Sumner region.

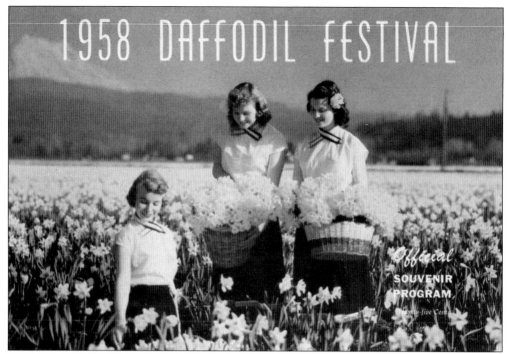

By the 1950s, the Daffodil Festival produced a souvenir program that cost 25¢. This program from 1958 read, "King Alfred welcomes you to the 25th annual Puyallup Valley Daffodil Festival, one of the earliest floral festivals in the nation, sponsored jointly by the four communities of Tacoma, Puyallup, Sumner and Orting." King Alfred is a variety of daffodil. (Courtesy of Sumner School District.)

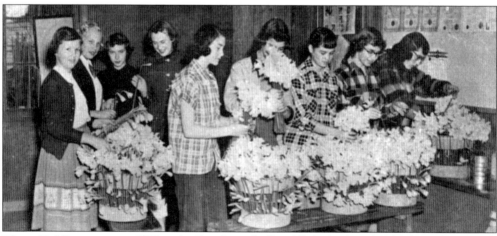

These Girl Scouts met in 1953 at the Boy Scout hall to fill the baskets for the festival. The girls are, from left to right, Frances Andrews, Linda Green, Linda Livesley, Donna Kaelin, Elaine Caviezel, Diane Scott, Marianna Vaughan, Marjorie Ziemer, and Enid Leibinger. The project was managed and supervised by L.M. Snow. (Photograph by *Sumner News-Index*, Courtesy of Robert Barnum.)

Corbin Fountain Lunch decorated extensively for the Daffodil Festival. Lots of businesses in Sumner and the other three cities supported the festival and benefited from its fame. Promoters touted that Sumner and Puyallup were nationally known for their hanging daffodil baskets. (Courtesy of Spartan Agency, LLC/Sumner Historical Society.)

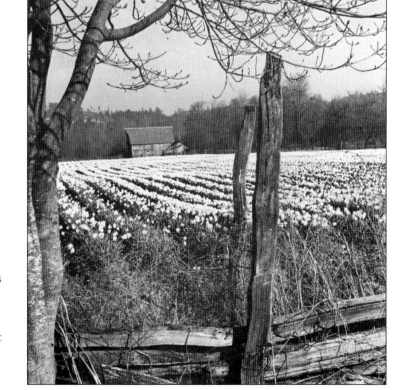

Daffodil growing in the valley began around 1925. The US Department of Agriculture recommended bulbs as an ideal crop for the valley's soil and weather. The farmers raised about 200 varieties, with King Alfred being the best-known and most common variety. (Courtesy of Sumner School District.)

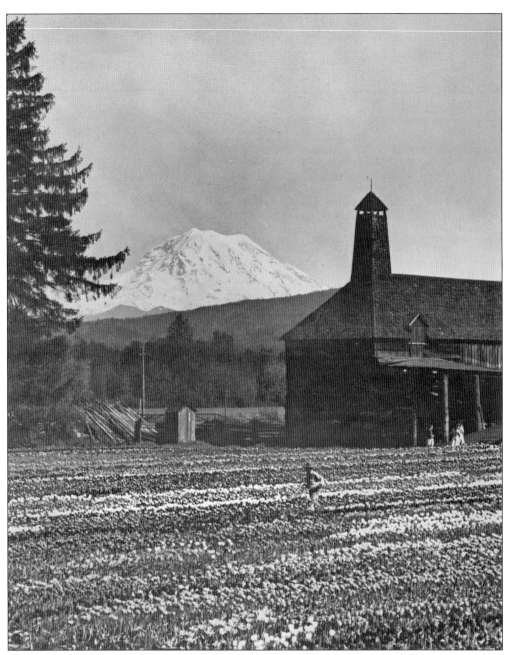

This photograph from the 1950s shows the transition of crops in and around the Sumner valley. In this field of daffodils, the barn was originally a hops barn. The hops blight stayed in the soil, which means that hops still cannot be commercially grown in the area, even 100 years later. Some of their telltale barns remain in the valley, however, and have been repurposed for other crops and uses. (Courtesy of Sumner School District.)

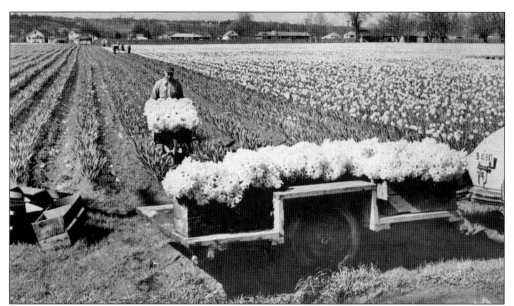

Daffodils were grown as a commercial crop for their bulbs, not for their flowers. One reason Lee Merrill suggested a parade in 1934 was because the flowers were being thrown away or used as fertilizer. By the 1950s, as seen in these two images, the flowers were harvested to decorate floats, cars, horses, and nearly everything else in the grand floral parade. (Both, courtesy of Sumner School District.)

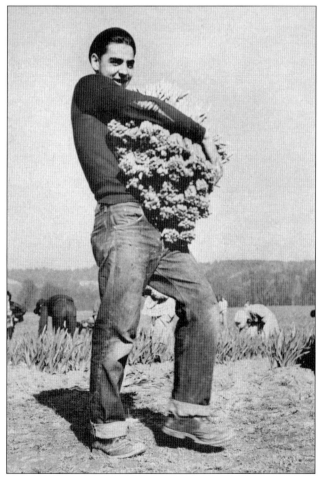

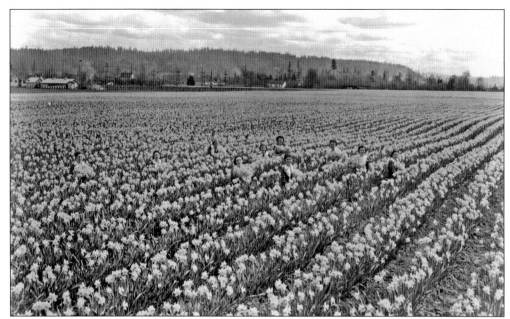

In this Richards Studio promotional shot for the 1936 Daffodil Festival, Sumner High School girls pose in some of the more than 500 acres of sunshine-yellow daffodils in the Puyallup Valley. (Courtesy of the Tacoma Public Library, Richards Studio Collection.)

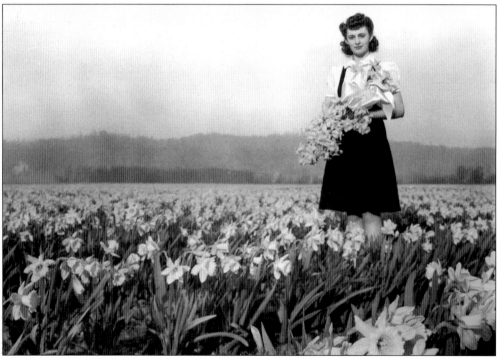

The 1941 Daffodil Festival queen, Pauline Martin, stands among acres of colorful daffodils while holding a beribboned bouquet. The 18-year-old Sumner High School student was the daughter of Mr. and Mrs. Paul Martin. Five newspaper photographers unanimously chose her as the new Daffodil queen from a field of 11 Sumner High School students. (Courtesy of the Tacoma Public Library.)

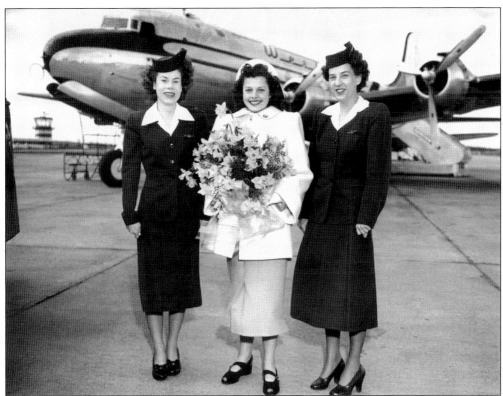

Doreen Moody, the 1948 Daffodil queen, leaves for California from Bow Lake Airport (now Seattle-Tacoma International Airport) for a two-day goodwill tour of California and Oregon. Moody, a Sumner High School junior, stopped in Portland, San Francisco, Oakland, and Warner Bros. Studios in Hollywood, and appeared as a guest on *Breakfast in Hollywood*, a recorded radio show. (Courtesy of the Tacoma Public Library, Richards Studio Collection.)

Margaret Thomas, the 1935 Daffodil queen, is seen here second from the left. The 23-year-old beauty represented Sumner in the pageant. The four attendants are, from left to right, Irma Jane Janig of Sumner, Olive Chervenka of Sumner, Billie Barto of Puyallup, and Evelyn Mellinger of Tacoma. The girls smile in the crisp spring weather as they wait for the parade to begin. (Courtesy of the Tacoma Public Library, Richards Studio Collection.)

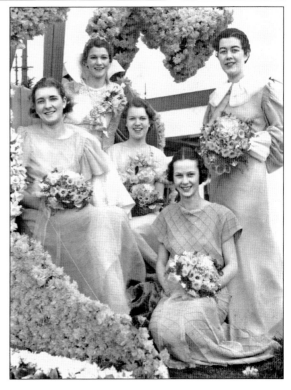

Sumner resident Margaret Thomas was crowned queen of the 1935 Daffodil Festival on March 22, 1935. She is seen here smiling at Frank Chervenka (right), a bulb grower and daffodil authority. Chervenka was also president of the Sumner Chamber of Commerce. Young Stewart Brown and Nancy Zech look on. (Courtesy of the Tacoma Public Library, Richards Studio Collection.)

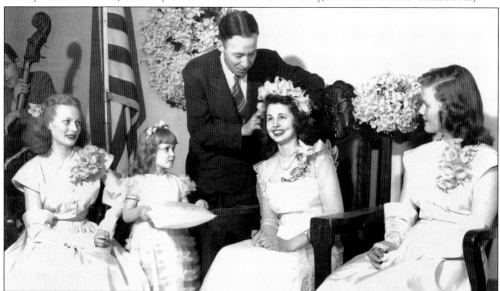

Gloria Dinwiddle of Sumner receives a crown of daffodils from Sumner mayor Harry Cain as he pronounces her queen of the 1946 Daffodil Festival. Attendants Patricia McPherson of Tacoma (right) and Maxine Barth of Puyallup look on. Caryn Chervenka, age four, is the crown bearer. The coronation took place at Guill Hall in Sumner at the Sumner VFW–sponsored ball. (Courtesy of the Tacoma Public Library, Richards Studio Collection.)

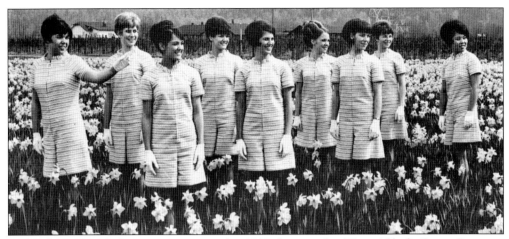

Styles changed with the times, as seen in this 1968 photograph of King Alfred's Court. Posing in the field in no particular order are queen Cheryl Lamka, Gwen Kawabata, Pamela Bartle, Karil Nayes, Inese Verzemnieks, Mardell Johnson, Judy Ehlers, Jennifer Anderson, and Susan Williams. Gov. Daniel J. Evans had the honor of crowning the queen at a ceremony held at Sumner's Spartan Hall. (Courtesy of Sumner School District.)

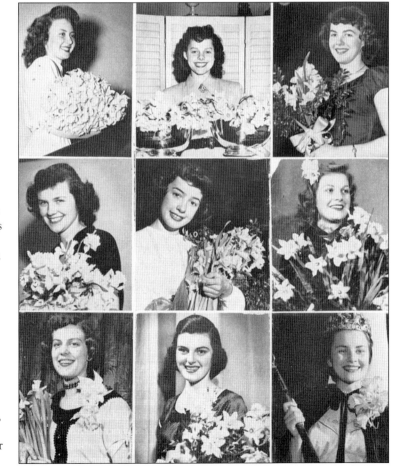

This recap of the queens from 1947 to 1955 shows Sumner's prominence. At that time, the queen was selected from 12 candidates, four each from Puyallup and Sumner High Schools and two each from Lincoln and Stadium High Schools in Tacoma. Sumner was home to the queen in 1948, 1950, 1952, and 1954. (Courtesy of Sumner School District.)

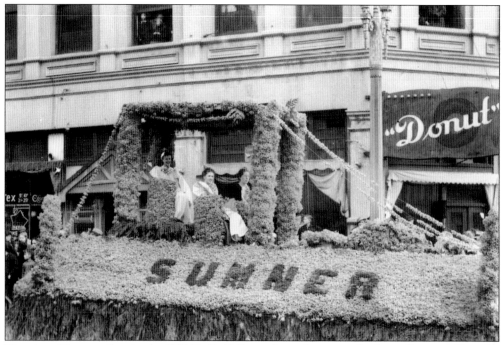

The city of Sumner float in the 1937 Daffodil Festival parade carries the festival's queen, Dorothy Lyons, and her two attendants. A total of 45,000 daffodils were used to decorate the float. It is passing a donut shop at Tenth Street on Pacific Avenue in Tacoma. (Courtesy of the Tacoma Public Library, Richards Studio Collection.)

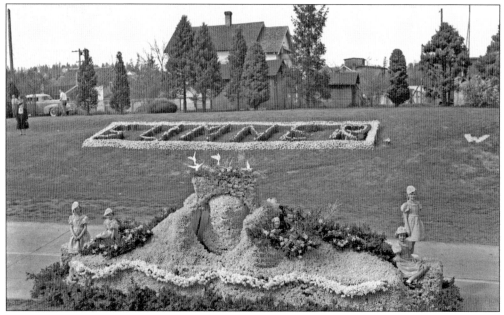

The sweepstakes winner in the 1940 Daffodil Festival was entered by the Tacoma Labor Council. The float is seen here while parading through Sumner and passing a grand floral welcome. It is on Thompson Street before Mountain Circle was built. More than 26 floats were entered in the 1940 parade. (Courtesy of the Tacoma Public Library, Richards Studio Collection.)

The Savings & Loan Associations of Tacoma float traveled down Sumner's Main Street in 1957. The float theme was "Pennies from Heaven" and featured 40,000 daffodil blooms—and 5,000 pennies. This is just one example of how many daffodils covered the floats. (Courtesy of Ernie Trujillo.)

Another float goes down Sumner's Main Street in 1957, with Sumner Auto Supply, at 909 Main Street, in the background. At that time, floats were judged 40 percent on appearance, 20 percent on originality, 20 percent for conformity to theme, 10 percent on artistic features, and 10 percent on detail. Floats are still judged today, and Sumner's community float routinely wins at least one award. (Courtesy of Ernie Trujillo.)

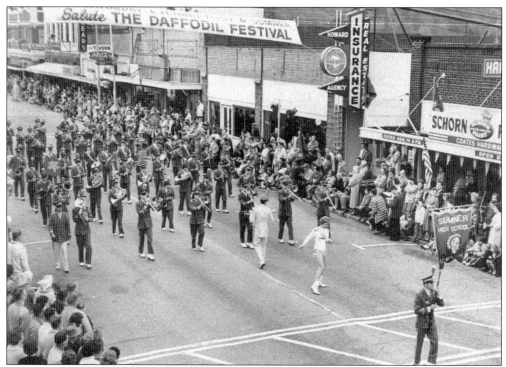

The Sumner High School marching band parades down Sumner's Main Street in the 1963 grand floral parade. Sumner's marching band has a proud tradition that continues today. They have marched in Pasadena's Tournament of Roses parade, the Portland Rose parade, and Seattle Seafair, but their home festival remains the Daffodil Festival parade. (Courtesy of Spartan Agency LLC.)

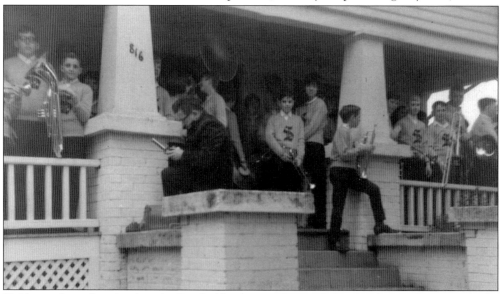

Holding a festival in April in the Pacific Northwest often includes the threat of rain. Here, the Sumner Junior High School band tries to stay dry while waiting their turn at the Daffodil parade in 1968. On the back of the photograph is written, "It began to pour so Jr. High Band ran onto our porch at 816 Kincaid." (Courtesy of H. Carol Anderson.)

Nine

HOLIDAYS AND
CELEBRATIONS

Sumner residents worked hard in business, industry, and agriculture, but they also knew how to celebrate together. Sports, arts, and social gatherings were a big part of life in Sumner. Recreational pursuits were shaped by the surrounding area, as popular pastimes included hunting, fishing, boating, and enjoying the mountains and Puget Sound, which are so close to Sumner. In fact, in the early 1920s, a sign posted by the cannery touted Sumner as the "Shortest Way to Rainier National Park."

Social gatherings also included dances, picnics, fairs, and a variety of other entertainment that Sumner citizens devised for themselves. A scrapbook from the 1920s, for example, shows tickets, programs, and newspaper clippings that tell of Chautauqua shows, glee club performances, operettas, and more. There are still regional football, basketball, and baseball games at home, as well as trips on the Blue Line buses to many destinations around Puget Sound and the Pacific Northwest. Invitations also often speak of dances. High School seniors camped on Vashon Island in 1922, where the newspaper reported, "Among the many exciting events that took place were the partial ducking of Lula Shriver, the finding of a crab in their bed by Kathryn Webber and Ruth O'Farrell, the disappearance of Mr. Davis' batteries, and the accident which gave Kathryn Maness a black eye."

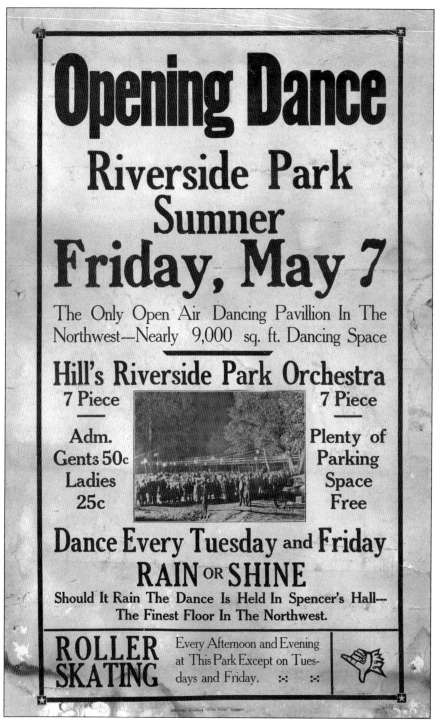

This poster advertises a dance at "The Only Open Air Dancing Pavillion in the Northwest." Although the exact location of the pavilion is unknown, it likely existed where Pierce County's Riverside Park is today, along the Puyallup River just south of Orton Farms and the Sumner city line. (Courtesy of Puyallup/Sumner Chamber of Commerce.)

Dok's Ragadours
THAT DIFFERENT ORCHESTRA
Music
For *All Occasions*
Dance WORK *A* SPECIALTY

Fone Sumner 12F12

Presented by
"*Phat*" Carter, Saxophone

In the days before modern stereo equipment, people in small towns made their own music. In 1924, Dok's Ragadours offered their music for all occasions. Amy Ryan writes about a Sumner town band in 1895 that included local business owners, including Tom Darr, Dr. J.H. Corliss, and Willard Goss. (Courtesy of Sumner School District.)

Sumner always decorated extensively for holidays, and still does today. In December 1951, Tom Meyers and Clyde Smith hung cedar rope and lights across Main Street while Dough Sandland held the enormous ladder. Today, Sumner's holiday decorations wrap around the streetlights instead of extending across the street, in order to keep the street clear for fire engines. Interestingly, Meyers served as Sumner's fire chief for years. (Photograph by *Sumner News-Index*, courtesy of Robert Barnum.)

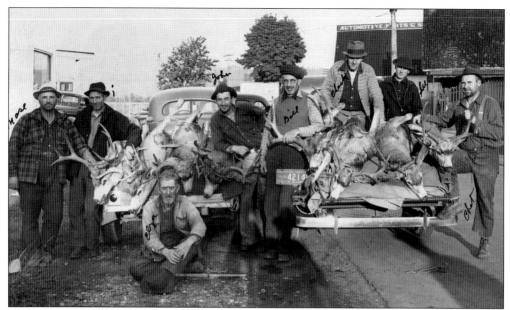

The surrounding Cascade Mountains greatly affect local recreational opportunities. Hunting remains a favorite pastime, although for many families through the years, it was more than a sport. The results of hunting were commonly stored in cool cellars or canned, to provide a family with meat all through the year. Here, a group of men display their deer in 1939. The trucks are parked along what is now Traffic Avenue. Zech's Garage, on Main Street, can be seen in the distance. (Courtesy of Mary Sanford.)

The T.A. Wright family displays a famous cougar that Wright shot on a hunting trip at Copper King, in the Carbon Glacier area. The cougar remained on display in the home at the top of the stairs and is now believed to reside at a museum in Greenwater. The Wrights moved to Sumner in 1888 and were distant cousins of Orville and Wilbur Wright. (Courtesy of Dave Curry.)

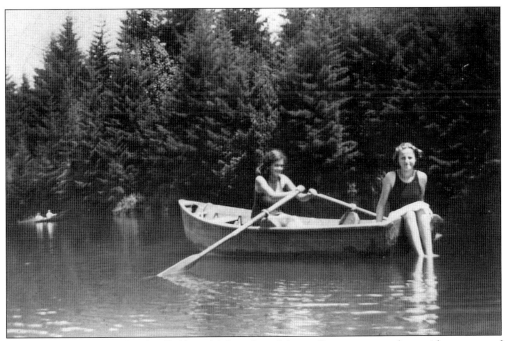

Sisters Della Morris Shanks (left) and Mary Jane Morris Pruitt enjoy a boat ride on one of Sumner's rivers around 1920. The girls are the granddaughters of "Grandpa" Messick, who had a farm between Algona and Sumner. (Courtesy of Kareen Shanks.)

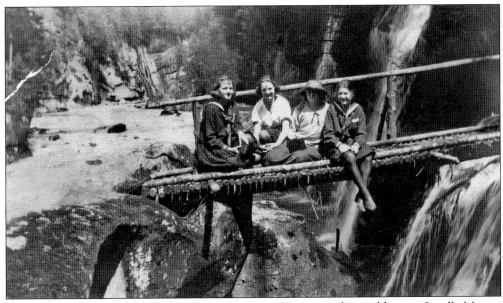

Sumner residents regularly ventured out of town to the surrounding wilderness. Lucille Merritt took this photograph of her friends at the Green River Gorge during the junior class picnic on May 22, 1922. (Photograph by Lucille Merritt, courtesy of Sumner School District.)

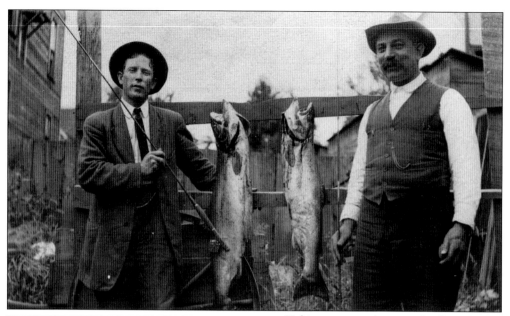

Fishing was another popular Sumner pastime, as seen here around 1910, with Johny Messick (left) and Bill Humens proudly showing off their catch. Fish were plentiful, not only in the Puyallup and White Rivers, but also in Salmon Creek. Today, fishing is still a big deal on the Puyallup River, especially when the salmon are "running." Salmon have also recently begun returning to Salmon Creek. (Courtesy of Kareen Shanks.)

Local children have always enjoyed riding their bicycles as a favorite pastime. Here, Charles Ocshner rides his tricycle on his father's dairy, near Salmon Creek along the East Valley Highway, in the 1930s. Tricycle designs have changed a bit since then. (Courtesy of Charles Ochsner.)

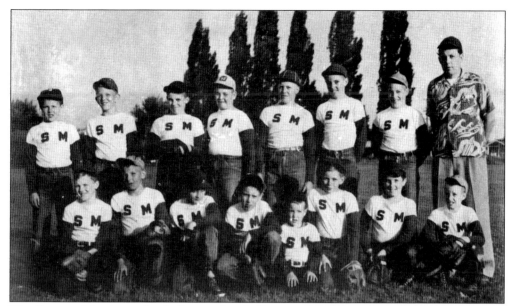

The Sumner Merchants Little League baseball team proudly poses in July 1952. The team included, from left to right, (first row) Randy Magley, Norman Strand, Doug Wing, Dale Pierce, Wayne Allen, Doug Burleigh, Larry Caddle, and Walter Wininger; (second row) Bud Barber, Roger Harkness, Jack Zehnder, Billy Ray, John Eilers, Bill Collier, Fred Weick, and manager Bob Northrop. (Photograph by *Sumner News-Index*, courtesy of Robert Barnum.)

Don Dawes, seen here, began the work of clearing for the Mountain Circle Park in July 1953. Architect Bill Johnson designed the park, and the Active Club built it. Unfortunately, in the 1960s, Highway 410 cut off the rest of Sumner from access to the park. (Photograph by *Sumner News-Index*, courtesy of Robert Barnum.)

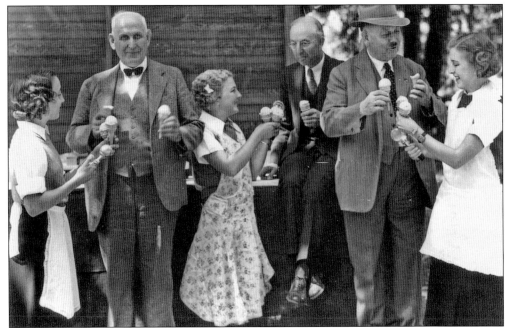

Three county commissioners, (from left to right) A.A. Rankin, John Schlarb, and Harvey Scofield, were all two-fisted cone eaters at the ninth annual Washington Cooperative Association picnic, held in Sumner on Friday, August 21, 1936. Between 2,000 and 3,000 farmers and grange members attended the all-day affair. They were served by, from left to right, Marion McChesney, Elsa Wahlquist, and Edna Wahlquist. (Courtesy of the Tacoma Public Library, Richards Studio Collection.)

Doris Lee appears comfortable sitting in the front basket of Bobby Seeber's bicycle. The youngsters are having ice cream cones at the ninth annual farmers' picnic in August 1936. A day off was declared by Pierce County farmers so that they, their families, and their friends could attend the Sumner picnic, sponsored by area agricultural organizations and the county agent's office. (Courtesy of the Tacoma Public Library, Richards Studio Collection.)

The May Day children's parade marches down Main Street in the 1950s. Jane Brazda recalls that mothers worked for weeks on costumes for kids. There was no theme; kids dressed up as they liked and proudly paraded down Main Street in the hope of winning a prize. (Courtesy of Spartan Agency, LLC/Sumner Historical Society.)

For the children's parade of 1965, Robert Divelbiss, age seven, and Sheryl Divelbiss, age four, stand in front of Corbin Fountain Lunch dressed as owners Waldo and Juanita Corbin. When the lunch counter closed in 1971, the newspaper described it as a place where "weighty decisions affecting the Valley's future have been made over Corbin's coffee." (Courtesy of Rosalee Divelbiss.)

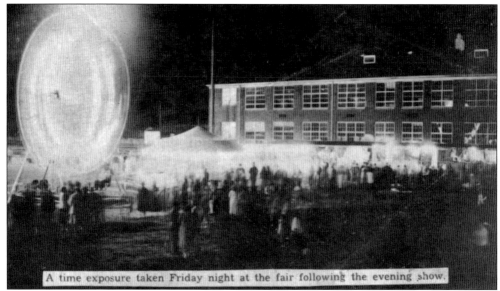

A time exposure taken Friday night at the fair following the evening show.

The Pierce County Junior Fair lights up a Friday night in the schoolyard in September 1953. Sumner residents were heavily involved in both this fair and the Western Washington State Fair in nearby Puyallup. The state fairgrounds include the W.H. Paulhamus Arena, named for the man who served as the fair's president from 1906 to 1925. Paulhamus resided at Maple Lawn Farm, at 313 Wood Avenue in Sumner. (Photograph by *Sumner News-Index*, courtesy of Robert Barnum.)

In April 1955, over 100 baton twirlers competed in the fifth annual Daffodil baton twirling contest. The competition was held in the Sumner Gymnasium on Wood Avenue. The winner, Sherill Francis of Sumner, was named "Miss Majorette of Washington" and advanced to compete in the national contest in August. (Courtesy of the Tacoma Public Library, Richards Studio Collection.)

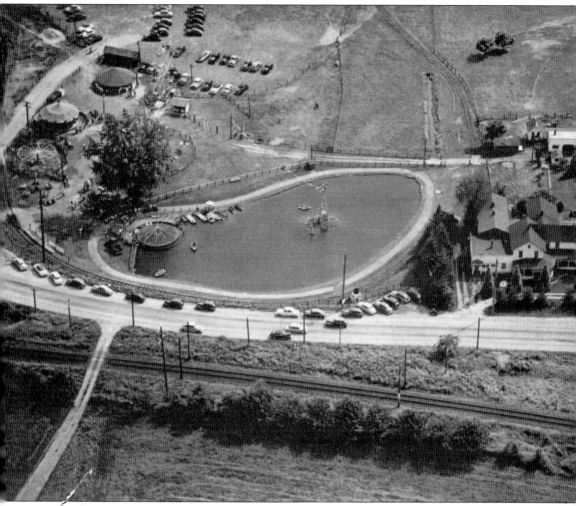

Pony Land Amusement Park delighted Sumner children from 1943 until 1954. Located on Valley Avenue toward Puyallup, just beyond the Sumner City Cemetery, the park was the dream of Herman Johns, who developed it and ran it until his death in 1954. He died of a heart attack while carrying a sick colt. The Sutters, who owned the land behind the park, bought Johns's land as well and farmed it. The pond, windmill, and round barn for the merry-go-round still exist on the site. To the right of the park is the building that served as the Chicken Dinner Inn before the park was built. As this road was the original route from Seattle to Tacoma, the inn enjoyed plenty of overnight business and was well known for its dinners. (Courtesy of Jane Brazda.)

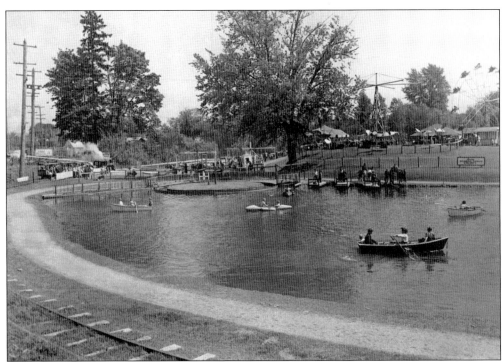

Pony Land Amusement Park featured a half-mile-long railroad, a pond with boats, a merry-go-round that spent winters at the B&I shopping center in Tacoma, an airplane ride, a Ferris wheel, pony rides, goats, mules, ducks, a monkey, and even an elephant, who also went to B&I when he got too big to handle. Kids loved the park, and Herman Johns would distribute tickets to kids who helped clean up areas of the park. Parents often had to find a new route between Puyallup and Sumner to avoid children pleading to stop at the park. (Both, courtesy of Jane Brazda.)

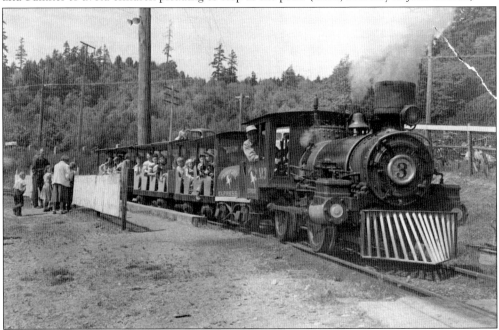

Ten

PEOPLE OF SUMNER

It is rather obvious to say that people make a community. However, it is also true that Sumner is a close-knit place where families stay for generation after generation. Many local people still have ties to pioneers and leading citizens of the past. Others came after the pioneers but have now lived in the town for a long time. Descendants of William Woolery, who came to Sumner in 1853 after crossing the Cascade Mountains with the first wagon train to try the Naches Pass, still reside in Sumner, as do descendants of many of Sumner's first families.

In addition to the well-documented lives of pioneers William Kincaid, George H. Ryan, Levant F. Thompson, and Woolery, other Sumner residents have distinguished themselves through lives of accomplishment. There are too many to name here, but the recent passings of longtime Sumner citizens like Arlene Peterson, Tim Hyland, Hazel Freehe, George Barnum, Mary Elizabeth Ryan, Jim Greenwood, Julie Moltke, and Gordy Anderson remind us that, while no one will be here forever, everyone shapes this community in some way.

Most people, of course, live lives that do not get noted in history books. Yet glimpses into these people's lives are valuable as illustrations of the way the majority live, the smaller contributions they make every day, and to provide a human context to the photographs of buildings that otherwise dominate our histories. The individuals, couples, families, policemen, minor officials, and other local characters who have gone before us fill in the blank streets and make the town come alive. Please meet just a few examples in this chapter.

Clara McCarty Wilt, the daughter of Ruth Kincaid and Jonathan McCarty, grew up on a farm across the Stuck River (now the White River) from downtown Sumner. She was a granddaughter of William Kincaid, the "father of Sumner," who brought his family by wagon train to settle this area in 1853. Clara's family moved to Seattle when she was 12, and she was the only member of the first graduating class of the University of Washington, in June 1876, making her the first UW graduate. She was elected superintendent of schools in Pierce County in 1879 and bought the first typewriter in Pierce County. (Courtesy of City of Sumner/Sumner Historical Society.)

Carrie Seaman Church, another of Kincaid's granddaughters, was born to Laura Kincaid and F.C. Seaman. Laura was only 16 years old when Carrie was born. Carrie married Henry Church in 1887 and had one daughter, Edith. During the flu epidemic, Carrie went to her daughter Edith's to help nurse her family. The rest of the family survived, but Carrie caught the flu and died of pneumonia on January 19, 1919. (Courtesy of Anne Sonner.)

Edith Church Veazie was born in Sumner in 1889. A great-granddaughter of William Kincaid, she lived in Sumner and attended schools here before her family moved to Spokane. Edith followed in her aunt Clara's footsteps, graduating from the University of Washington in 1911 with a bachelor of arts and a teaching certificate. In 1912, she traveled through Europe on the *Lusitania* with her aunt and uncle, Sue Meade and Dr. E.M. Anderson. She married Rev. Carl Hewitt Veazie in 1916 in Idaho and died in 1950 at age 61. (Courtesy of Anne Sonner.)

121

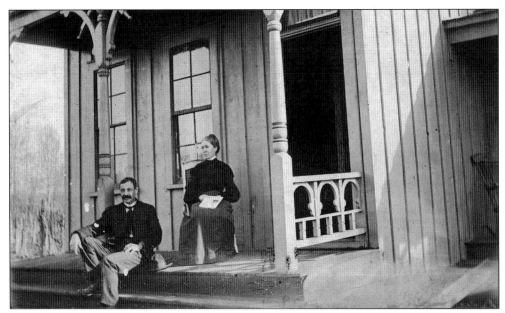

Lachlan and Jessie Macintosh pose for a photograph at their Sumner home in 1904. Lachlan was born in Scotland around 1857 and became an American citizen in 1883. In 1910, their nephew Lee Morris lived with them at 632 La Grange Street, which was one block south of Harrison Street and was later replaced by Highway 410. In 1924, Lachlan Macintosh visited his native Scotland and came back home via the SS *Montreal.* (Courtesy of Kareen Shanks.)

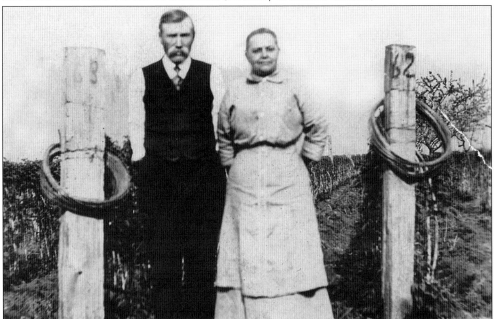

Ferdinand and Mary Streblow pose in April 1916 on their raspberry farm at Streblow's Corner, which is now the site of the Valley Avenue exit off of Highway 410. Mr. Streblow came to Sumner in 1902 and, according to the July 29, 1912, edition of the *Tacoma Times,* served as a judge for "Sumner Precinct, Outside," as appointed by the Pierce County Board of County Commissioners. (Courtesy of H. Carol Anderson.)

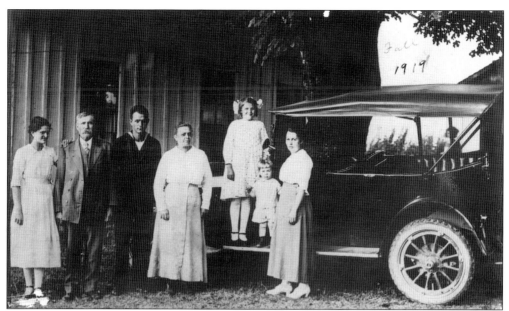

The Streblow family is seen here in fall 1919 at Streblow's Corner. From left to right are Bertha, Ferdinand, Ralph, Mary Caroline (Lindstrom), Helen, Richard Quantz, and Esther Streblow Quantz. Note that Ralph Streblow is wearing his Navy uniform. The photograph was taken just after the end of World War I. (Courtesy of H. Carol Anderson.)

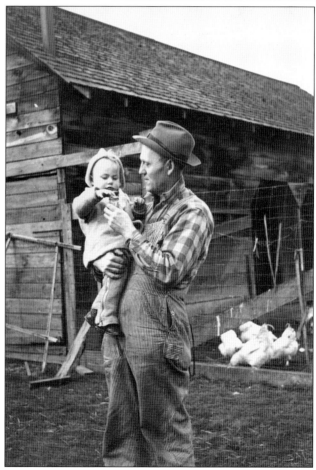

Many families were affected by the world wars, including both George Barnum Sr. and George Barnum Jr. George Sr. came through Sumner after World War I and stayed when he met his wife. George Jr. fought in World War II. Because he knew the German practice of layering food within dirt mounds, he was able to find food when he and other American soldiers crossed the Black Forest as prisoners of war. (Courtesy of Robert Barnum.)

Leroy Goff moved to Sumner as a young boy and also served in World War II. Goff was in the Navy before coming home to Sumner to raise his family, work at the Fiberboard Corporation, drive an ambulance, and serve as mayor and councilmember. He retired from public service in 2011. He is seen here with wife, Beverly Ann, and his two oldest children, Roger Dale Goff and David Carl Goff. (Courtesy of Leroy Goff.)

The Cold War touched Sumner as well. In 1954, the Sumner Civil Defense Wardens were proud to be the first in Pierce County to receive their hats. The wardens were, from left to right, county warden director Chuck Boneske, Edwin Fischer, Earl Oakes, Andrew "Jack" Riddell, Neal Torrey, Harold Dinger, Arlen Herbst, Joe Fosnick, Marcella Herbst, Louie Peterson, Howard Schrengohst, LeRoy Shuler, H.J. Beane, Ed Keenan, Lute Goodwin, and Chuck Haydon. (Courtesy of *Sumner News-Index*.)

From left to right, Sumner citizens Lt. Wally Staatz, Sgt. Jack Huntington, and Sgt. Wayne Jorgensen work on completing a special two-week training program in 1953. The program was part of the annual National Guard summer encampment at Camp Murray. (Photograph by 41st Signal Corps, reprinted in *Sumner News-Index*, courtesy of Robert Barnum.)

In 1953, city officials inspected the new one-million-gallon city reservoir. From left to right are Howard Flanagan, city engineer; Dwire Garrett, fire chief; Erwin Yoder, councilmember; J.T. Stahlhut, mayor; Fred Tebb, councilmember-at-large; Arthur Charnock; Neil McClane, councilmember; and Gatts Lewis, police chief. (Photograph by *Sumner News-Index*, courtesy of Robert Barnum.)

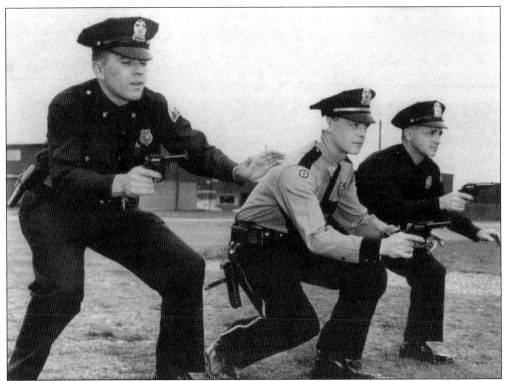

Three Sumner police officers, with officer Douglas Fraser in the middle, pose for a photograph in 1963 that appears to have been influenced by the popularity of police television shows. Several Sumner police photographs show officers in this pose, including one tongue-in-cheek recreation done by officers in 2004. (Courtesy of Sumner Police Department.)

In 1951, firefighters served a turkey dinner. They are, from left to right, Scott Kuss, Leroy Haase, Don Reeves, Don McMillan, Tom Myers, Gene Harris, Bud Goodman, Gordon Hurd, and Fred Riddell. Myers later served for many years as Sumner's fire chief. (Photograph by *Sumner News-Index*, courtesy of Robert Barnum.)

William P. Bonney (left) of the Washington State Historical Society poses with William Woolery of Sumner. By the time this photograph was taken, in 1935, Woolery was one of the few surviving members of the first wagon train to cross the Cascade Mountains. The train crossed at Naches Pass in 1853, completing its journey from Missouri to Puget Sound. (Courtesy of the Tacoma Public Library, Richards Studio Collection.)

Dr. Pat Duffy Sr. joined in practice with Dr. Chuck Denzler and Dr. Tom Clark at 911 Kincaid Avenue on January 1, 1952. By the time of his retirement in 2004, Dr. Duffy had delivered more than 2,000 babies, and, in 2013, celebrated his 60th year with Sumner Rotary. His own family lived on Wood Avenue before moving to Voight Avenue. Seen here from left to right are Steve, Kevin, Pat Sr., Cathy, Brian, Joan, Pat Jr., and Idris Duffy. (Courtesy of Pat Duffy Jr.)

DISCOVER THOUSANDS OF LOCAL HISTORY BOOKS
FEATURING MILLIONS OF VINTAGE IMAGES

Arcadia Publishing, the leading local history publisher in the United States, is committed to making history accessible and meaningful through publishing books that celebrate and preserve the heritage of America's people and places.

Find more books like this at
www.arcadiapublishing.com

Search for your hometown history, your old stomping grounds, and even your favorite sports team.

Consistent with our mission to preserve history on a local level, this book was printed in South Carolina on American-made paper and manufactured entirely in the United States. Products carrying the accredited Forest Stewardship Council (FSC) label are printed on 100 percent FSC-certified paper.

MADE IN THE USA